Artist's
Photo Reference
REFLECTIONS, TEXTURES
& BACKGROUNDS

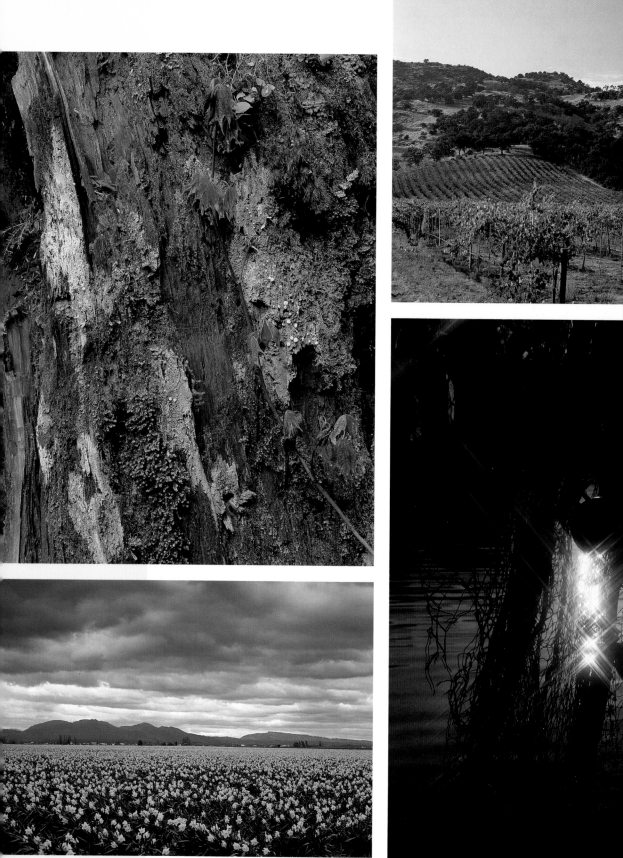
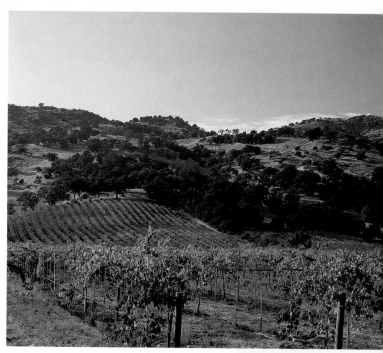

Artist's
Photo Reference
REFLECTIONS, TEXTURES & BACKGROUNDS

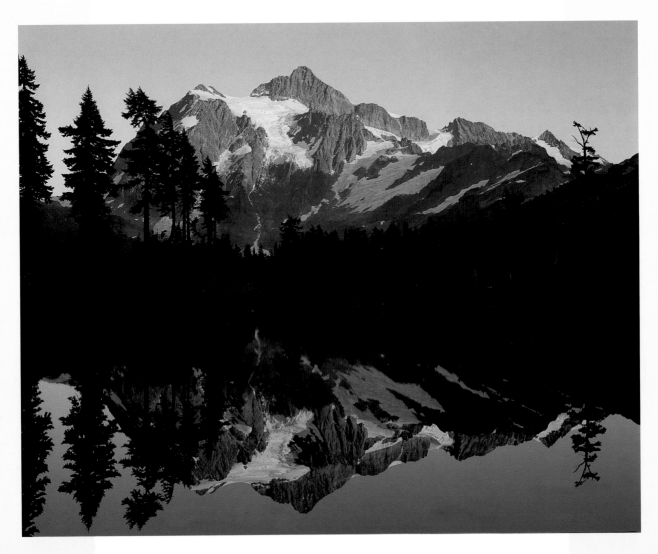

GARY GREENE

NORTH LIGHT BOOKS
Cincinnati, Ohio
www.artistsnetwork.com

About the Author

In addition to being an accomplished professional photographer for over twenty years, Gary Greene is a talented fine artist, graphic designer, illustrator, author and instructor. Specializing in outdoor photography, Gary's photographs have been published by the National Geographic Society, Hallmark, Quest, the Environmental Protection Agency (EPA), Hertz, the Automobile Association of America (AAA), *Petersen's Photographic* magazine, *Popular Photography* and *Northwest Travel*. Gary has worked in a number of fine art mediums, including acrylic, airbrush, colored pencil and ink.

In addition to *Artist's Photo Reference: Boats & Nautical Scenes*, Gary is the author of *Artist's Photo Reference: Buildings & Barns; Artist's Photo Reference: Landscapes; Artist's Photo Reference: Flowers; Creating Texture in Colored Pencil; Creating Radiant Flowers in Colored Pencil* and *Painting with Water-Soluble Colored Pencils*, all published by North Light Books. Gary's colored pencil paintings and his photographs have won numerous national and international awards. He has conducted workshops, demonstrations and lectures on photography and colored pencil since 1985.

Other fine North Light Books are available from your local bookstore, art supply store or direct from the publisher.

08 07 06 05 5 4 3 2

Library of Congress Cataloging in Publication Data
Gary, Greene.
 Artist's photo reference. Reflections, Textures & Backgrounds/Gary Greene—1st ed.
 p. cm.
 Includes index.
 ISBN 1-58180-377-X (alk. paper)
 1. Photography, Artistic. 2. Reflections. 3. Texture (Art) 4. Painting from photographs
I. Title.

TR642.G695 2004
701'.8—dc22

2003059351
CIP

Edited by Vanessa Lyman
Cover design by Anna Lubrecht
Interior design and production by Lisa Holstein
Production coordinated by Mark Griffin

Metric Conversion Chart

To convert	to	multiply by
Inches	Centimeters	2.54
Centimeters	Inches	0.4
Feet	Centimeters	30.5
Centimeters	Feet	0.03
Yards	Meters	0.9
Meters	Yards	1.1
Sq. Inches	Sq. Centimeters	6.45
Sq. Centimeters	Sq. Inches	0.16
Sq. Feet	Sq. Meters	0.09
Sq. Meters	Sq. Feet	10.8
Sq. Yards	Sq. Meters	0.8
Sq. Meters	Sq. Yards	1.2
Pounds	Kilograms	0.45
Kilograms	Pounds	2.2
Ounces	Grams	28.3
Grams	Ounces	0.035

Dedication

For Grrtrude:
She's full of sugar,
She's full of spice,
She's kinda naughty,
But she's naughty and nice.

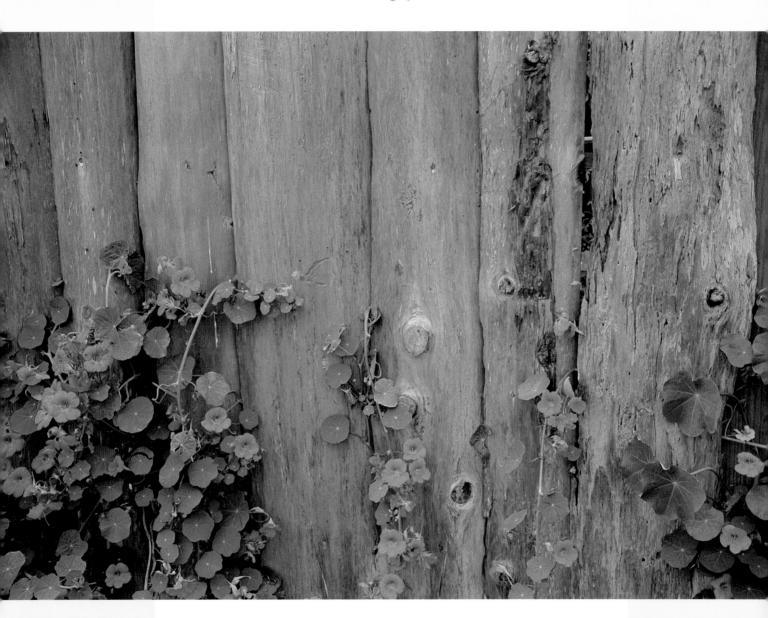

Acknowledgments

Special thanks to my dear friend, Norma Auer Adams, for allowing me to photograph some of her "treasures" for this book and to my only wife, Patti, for stickin' all those labels on my slides.

Table of Contents

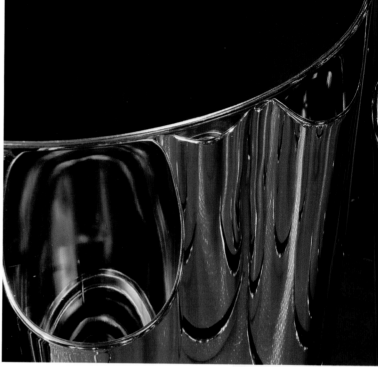

CHAPTER ONE

Reflections17

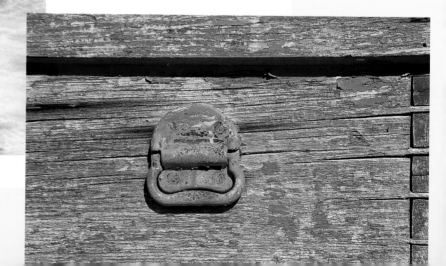

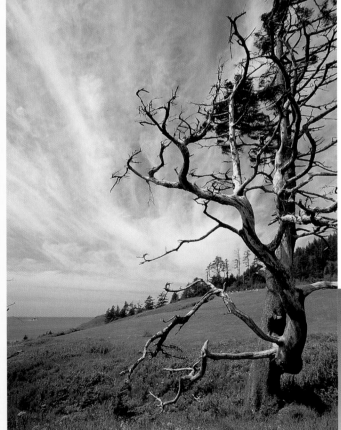

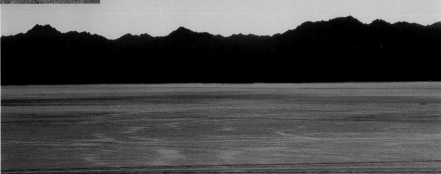

Introduction

Artist's Photo Reference: Reflections, Textures & Backgrounds could have as easily been titled, *Artist's Photo Reference: Potpourri,* because it contains a broad mix of subjects for painting or drawing projects. It is intended to provide you, the artist, with images that will help you understand subjects, save valuable time in finding particular subjects, to complement your own library of reference photos, and to stimulate your creativity, both photographically and artistically.

In the *Textures* section, there are natural textures such as rocks, water, bark, leaves and clouds; and man-made textures like glass, wood, metal and fabric. *Backgrounds* includes landscape elements: skies, bodies of water and mountains, plus abstracts and silhouettes. The *Reflections* segment contains reference photos of objects reflected in water, metal and glass, plus various shadows.

Many of the reference photos in this book can be interchanged. For example, a photo of clouds could be used for a texture study or as a background in a landscape painting.

A number of reference photos were made "on the spot," with the sole intention of using them as references or as an ingredient in a painting without consideration for photographic correctness, such as composition, lighting or color accuracy.

In order to capture valuable images, my camera is always nearby. Whenever I see something interesting, I photograph it whether I have an immediate use for it or not. At a later date, when I need a detailed study of, say, a weathered wood fence, I go to my photo library and choose examples to work from. *Artist's Photo Reference: Reflections, Textures & Backgrounds* contains many of the images I have collected over the years.

As in the other *Artist's Photo Reference* books, the images are interspersed with step-by-step project demonstrations created by talented professional artists working in the major mediums. They have interpreted various textures, backgrounds or reflections in their own unique styles.

Gary Greene
Woodinville, Washington
April 2003

How to Use This Book

Unlike the photos in the other books in the *Artist's Photo Reference* series that specialize in specific subjects, the reference photos in this book can be found just about anywhere you look. The secret is to be able to recognize them. A trip to the grocery store can offer a variety of fruits and vegetables to shoot as models for still lifes. At a marina, find ever-changing reflections in the water. Antique stores offer a treasure chest of subjects to add to your reference library, but be sure to ask permission before photographing. *Artist's Photo Reference: Reflections, Textures & Backgrounds* gets you started with useful photos as references for paintings plus provides ideas for making your own reference material.

Artists often ask if they violate copyright laws by using the photos in this book. The answer: Only if they are copied exactly and if the copied photo is publicly displayed, reproduced or offered for sale. It is okay to freely "borrow" from the reference photos; just alter the image so it can't be identified as the original photo. Making enlarged copies of the reference photos is permissible, so if an employee at a copy center balks at making photocopies, show them this: ***It is permissible to make photocopies of the photographs in this book.***

Most of the photos in this book are references, depicting the detail or structure of a subject. They may not be properly composed or photographed under the best lighting conditions—additional reasons why they should not be copied exactly. The images are intended to be a handy reference tool for various reflections, textures and backgrounds, not considered as works of art in themselves, photographic or otherwise.

As in other books in this series, *Artist's Photo Reference: Reflections, Textures & Backgrounds* includes six demonstrations by professional artists working in various mediums and styles showing how they interpret reference photos of reflections, textures or backgrounds. These demonstrations are also designed to illustrate how reference photos can be used creatively.

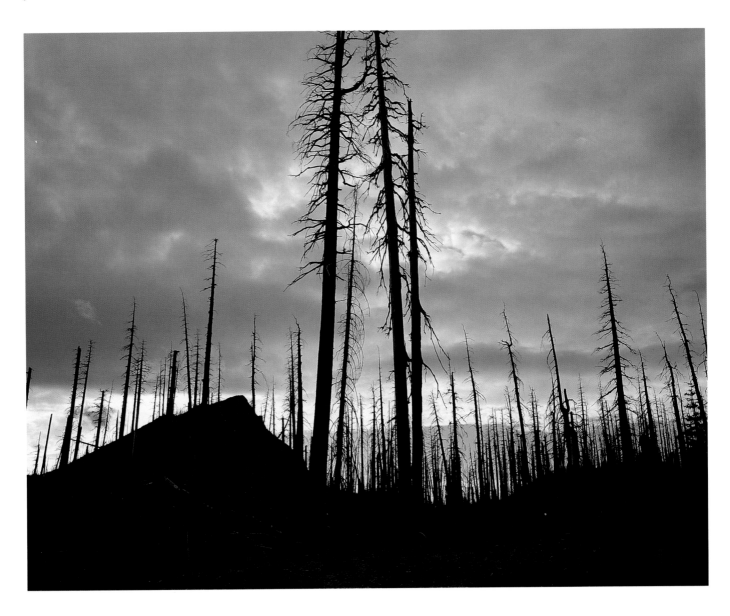

Taking Your Own Reference Photos

Unless you specialize in nonrepresentational art, having your own original photographs to work from should be a major part of your repertory. Shooting reference photos can be just as exciting and creative as actually painting.

Each of the three topics in this book requires a different method of shooting and a few pieces of specialized equipment. Let's cover the basics first.

Cameras—Film vs. Digital

The digital camera is the most revolutionary product to impact photography since Kodak's Brownie over seventy-five years ago. Digital cameras offer the convenience of no film, no processing, and—depending on the size of the memory card—hundreds of shots in your camera. Some of the newer "high-end" SLR (Single Lens Reflex) digital cameras produce images that rival and even surpass 35mm film in sharpness and color accuracy.

Should you use a digital camera for reference photography? The answer is a qualified "yes." All reference photos should be sharp, especially texture studies. In order to get the level of detail

required for this kind of work, a digital camera with a resolution of at least six mega pixels is required. At this writing, the cost of a six mega pixel digital camera starts at about $850, with capabilities roughly equivalent to a $350 35mm film camera. A digital camera must be set to the highest resolution in order to obtain acceptably sharp prints. This greatly reduces the number of shots available, resulting in either frequent downloading (not convenient without a computer nearby), or the expense of additional or larger memory cards. High-resolution images result in larger files that make a very large dent in an older computer's hard drive, requiring a new hard drive, an additional external hard drive, a CD or DVD burner, or a new computer.

You will also need prints of your digital images. Should you send your digital images to a photo lab or copy center and pay for prints that may not be satisfactory, or should you buy your own printer? Satisfactory ink-jet photo printers start at around $350. Do not forget that paper and ink cartridges must also be replaced regularly. It is cumulative

Suggested Equipment
Approximate prices as of this publication are given in parentheses.

35mm SLR camera ($200 up)
100mm Macro Lens ($600)
28-200mm Wide angle to telephoto zoom lens ($200)
Protective filter: 81A ($25 up)
Tripod with ball head and quick release ($150 up)

expenses like these that make digital photography a "qualified" choice. The decision is, "Is the expense worth the convenience of digital imaging?"

Although not as convenient, film is still a better choice over digital photography, because initial investments are less, and, more importantly, it usually produces sharper images.

A 35mm SLR camera is a must for reference photography. It offers interchangeability of a wide variety of lenses of different focal lengths and permits exposure choices, plus many other options that improve your chances of successful photography.

Reliance on auto exposure, even with sophisticated cameras, usually results in improperly exposed photos. Most modern SLR cameras have autofocus, which may not always be useful for these subjects.

In choosing cameras and lenses, you will find that equipment produced by major manufacturers (i.e., Canon, Nikon, Minolta, Pentax) is of excellent quality with a wide range of prices based on the number of features.

Point-and-shoot cameras should not be used for reflections, textures and background reference photos because they usually have less efficient optics and versatility. Most point-and-shoot cameras do not offer important features like manual exposure or external flash capabilities.

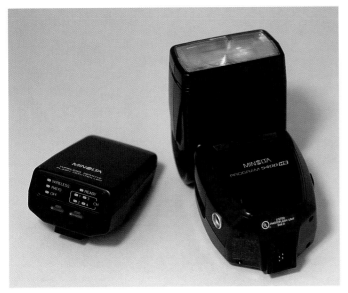
Electronic Flash

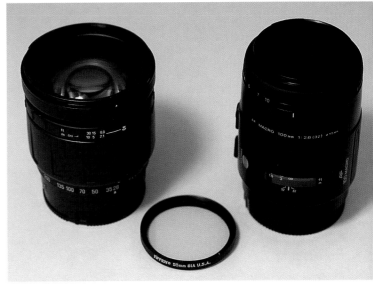
Filters

Electronic Flash

For textures, an electronic flash system is an essential tool. Almost all indoor subjects require flash because of insufficient light, and a tripod may not be practical because of limited space. Choose a flash unit *dedicated* to your camera, one that automatically adjusts its output based on the camera's settings. A wireless remote control is very useful but not a necessity.

Tripod

A sturdy tripod may be necessary to get sharp, detailed pictures in low lighting situations, particularly when photographing landscape backgrounds. Instead of the standard pan head that most tripods come equipped with, refit the tripod with a ball head and quick release; it makes using it relatively hassle-free. Ball heads allow easy camera positioning and a quick release has a small plate that attaches to the bottom of the camera that locks it onto the tripod without fumbling with a screw mount. The camera is easily released from the tripod by merely flipping a lever.

Filters

A filter should be attached to the front of your lenses to protect the front element from dust and scratches. Many photographers use a clear Ultraviolet (UV) or Skylight filter, but an 81A filter is a better choice. Its pale orange color "warms up" photos without drastically altering them, which is particularly useful on overcast days.

What Film Should You Use?

The following are suggestions for films best suited to photograph reflections, textures and backgrounds. Slides are preferable to prints because they produce sharper photos and more accurate color. Some artists paint directly from slides viewed through an inexpensive

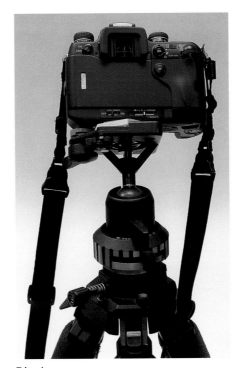
Tripod

photographer's loupe. A slide is placed in a clear acetate sleeve and taped to a 10X loupe, and when it is held up to a light source, the slide is magnified to an equivalent of an 8" × 10" (20cm × 25cm) print, but with considerably more detail. This method is particularly useful when painting textures. Slides are less costly and are easier to store. Prints made from slides (called "R" prints) are equal in quality to prints from negatives.

Print film is more "forgiving" than slide film, because you can miss the correct exposure by a greater margin and still have a usable photo. However, print film is more vulnerable to printing errors in the lab, resulting in poor color, incorrect exposure, or both.

A film's speed (ISO) determines how sensitive it is to light. The faster the film (the higher ISO number), the more light sensitive it is, which enables the photographer to shoot at higher shutter speeds, sometimes making a tripod or electronic flash unnecessary. However, faster films have larger light-gathering particles in their emulsion, producing grainier and less sharp photos.

Suggested slide films are: Fujichrome Velvia (ISO 50) and Provia F (ISO 100). These films are among the sharpest films available and produce brilliant colors, even on overcast days. They are professional films available only at camera stores or photo labs.

Choosing the Right Lens

Choosing the Right Lens

Making reference photos of reflections, textures or backgrounds each may need a special lens for the best results.

Reflections

Reflections are best photographed with telephoto zoom lenses with focal lengths from 100mm and up. As an example, water and reflections off windows are far enough away that they may require cropping. A wide angle to telephoto zoom lens, such as a 28-200mm will meet ninety percent of a reference photographer's needs. These lenses are relatively inexpensive but have less light-gathering ability. A long telephoto zoom in the 100-400mm range can bring in scenes even closer, but they are expensive, slow and, in most cases, require a tripod for adequately sharp photos.

Textures

Textures usually require the use of a macro lens, which is designed for close-up work. Macro lenses are generally available in two fixed focal lengths: a 50mm "normal" focal length and a 100mm short telephoto focal length. The 100mm lens is more desirable because it allows a little distance between you and the subject, it allows for same size (1:1) magnification ratios without additional attachments, and it can also be used as a superb portrait lens. The disadvantage of macro lenses is their expense; a 100mm macro has a street price starting at around $600 and a 50mm, about $250.

Zoom lenses offering "macro focusing" are not true macro lenses because they do not have the capability of making same-size magnifications and do not get that close to the subject. They are also much "slower"; that is they have less efficient light-gathering capabilities.

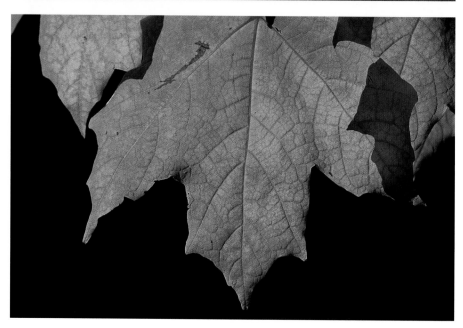

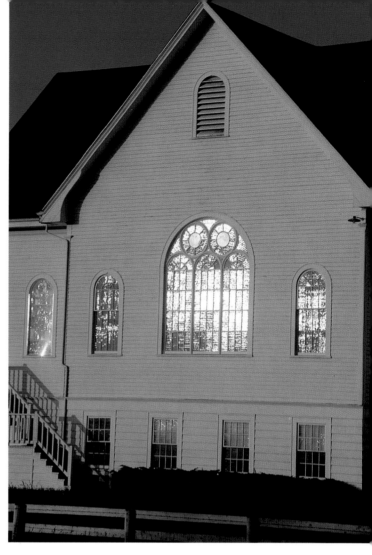

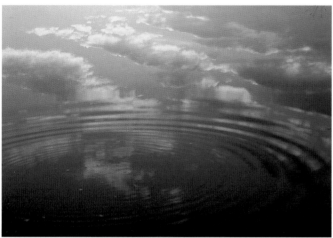

An inexpensive alternative for close focusing is close-up filters that screw onto the end of the lens. They are available in different magnification powers, such as +1, +2 and +4. They can be used singly or stacked together, but do not produce images nearly as sharp as a macro lens.

Backgrounds

Backgrounds cover such a wide range of subjects that it is difficult to specify what type of lens will work best, but generally a wide angle to telephoto zoom lens like a 28-200mm is a good bet for landscapes, clouds and bodies of water. A zoom lens also comes in handy for abstracts, allowing you to zoom in and out while making a long exposure.

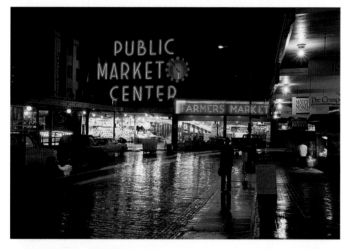

Shooting Successful Reference Photos

Making photographs can be as much fun as painting and drawing when you use your own photographs as subjects. Unlike other subjects covered by the *Artist's Photo Reference* series of books, *Reflections, Textures & Backgrounds* offers such a large field of material, subjects can be found anywhere and anytime. Because these subjects are usually used for either reference or as an ingredient in a painting, attention to composition, lighting and precise color is not as critical as when shooting specific subjects.

The most important consideration in photographing textures is detail, so it is important to shoot with fine-grain film and the smallest possible f-stop to be sure everything is in sharp focus. This requires using either electronic flash or a tripod.

Reflections also require small f-stops especially when trying to capture reflections in the subject you are shooting. Reflections in water may require fast shutter speeds in order to freeze the water's movement. When photographing intense reflections, such as the sun shining on windows, care should be taken to expose for a similar area without the reflection to avoid severe underexposure.

Landscape backgrounds, such as mountains, rivers, lakes, clouds, etc., should be composed from different vantage points and with different exposures. Silhouettes make good backgrounds and can be backlit subjects on sunny days; just be sure to give your exposure one to two extra f-stops to prevent underexposure. Overcast conditions also offer an excellent opportunity for silhouettes. Overexpose the scene so the gray overcast background will result in clear areas on your slides. Long exposures of colorful reflections on moving water can make great backgrounds.

Interesting backgrounds can easily be made by overexposing scenes that have strong contrasts in value or color, such as gardens, fall foliage, crowds of people or neon signs, by throwing your camera out of focus, by zooming or intentionally moving the camera while making long exposures or making multiple exposures, if your camera has the capability. These tricks can be combined, or invent your own. Who knows, photography might be so much fun, you may want to throw your brushes away!

Creating Composite Photos

Reference photos can be combined to create exciting new images. This can be accomplished by traditional methods, such as physically cutting and pasting photos, or the images can be made on a computer, using photo-editing software like Adobe PhotoShop. As personal computers become more commonplace, artists are becoming more proficient with them. Not long ago, image-editing programs like Adobe PhotoShop were a mystery to everyone except experienced designers, illustrators and photographers. Today, many artists use image-editing software to alter or enhance photos.

Reflections, textures and backgrounds naturally lend themselves to composite reference photos. If slide film is used, composite photos can be "sandwiched" from two or more slides. For example, a silhouetted scene with a clear background can be sandwiched with another background, texture or reflection to produce an interesting composition.

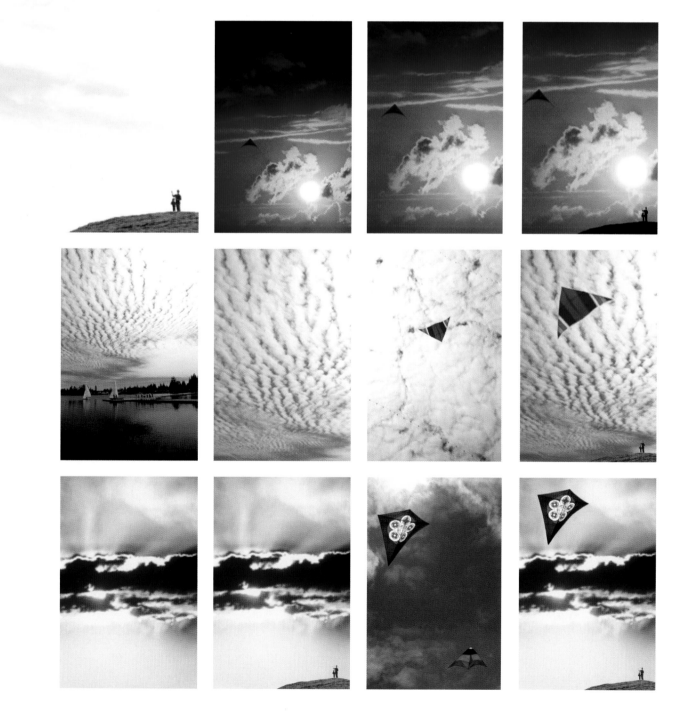

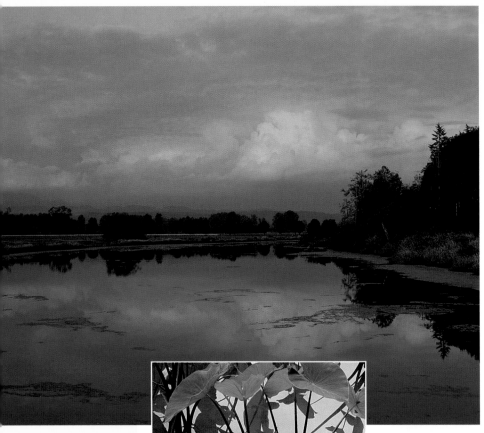

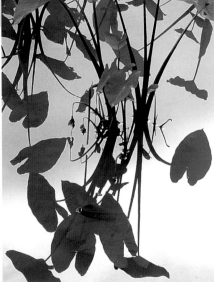
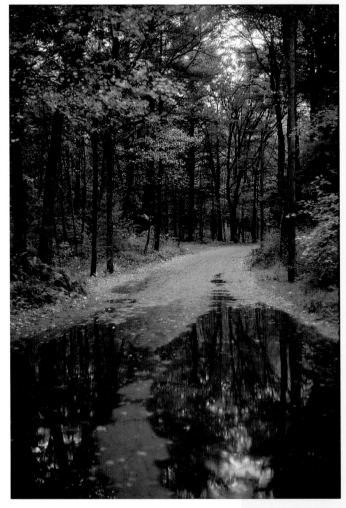
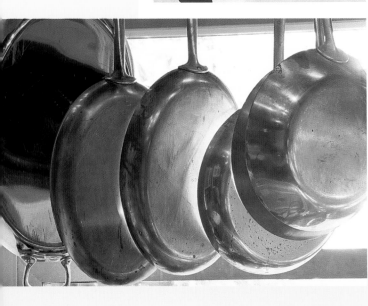

CHAPTER 1

Reflections

These reference photos demonstrate how light is reflected from different surfaces. Brilliant sunlight and various objects reflecting on water shown in various settings, plus reflections on windows and other objects are depicted here. As in the other sections of this book, many of the reflections in this section can be used as texture studies or backgrounds.

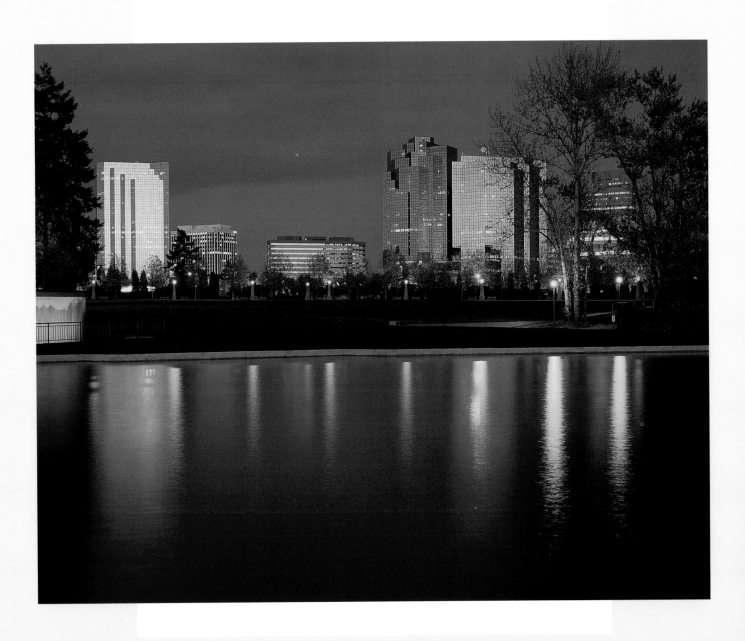

Buildings and Bridges Reflected in Water

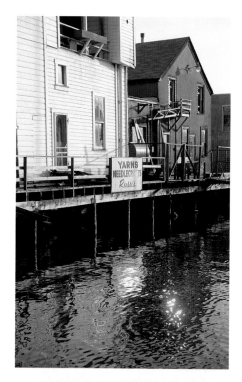

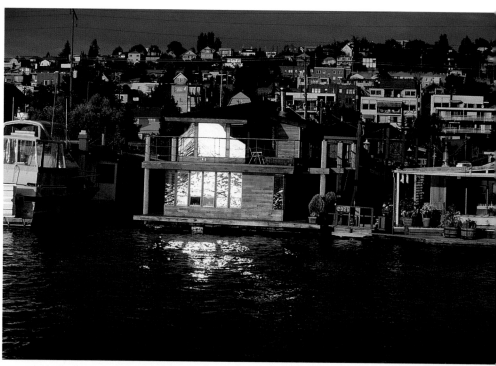

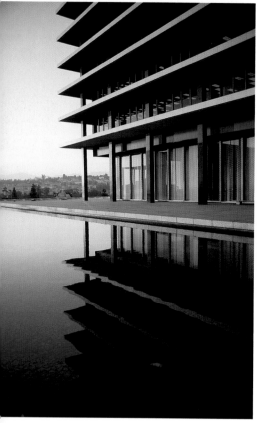

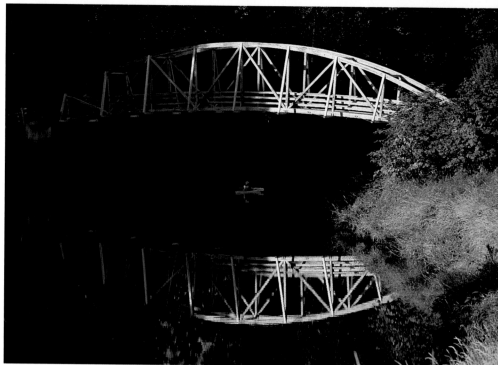

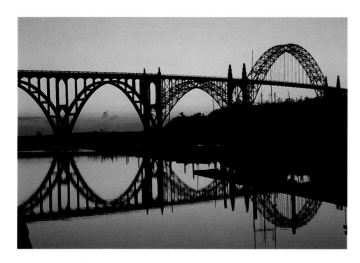

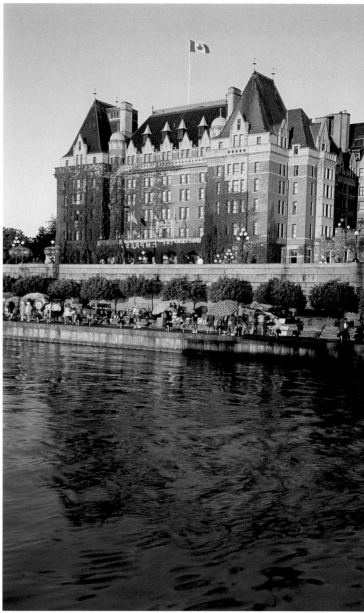

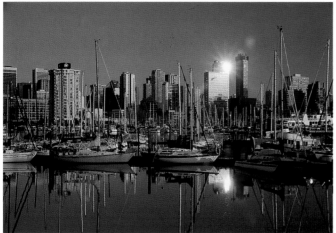

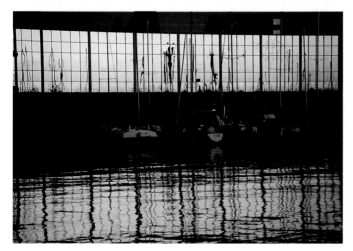

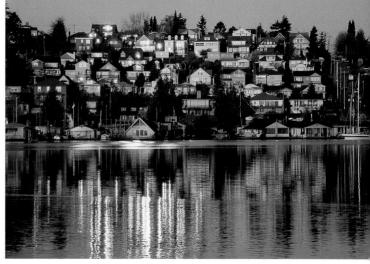

Lights on the Water

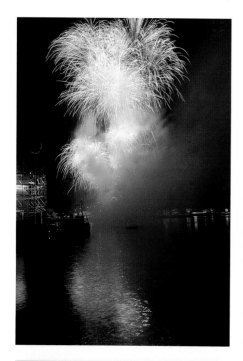

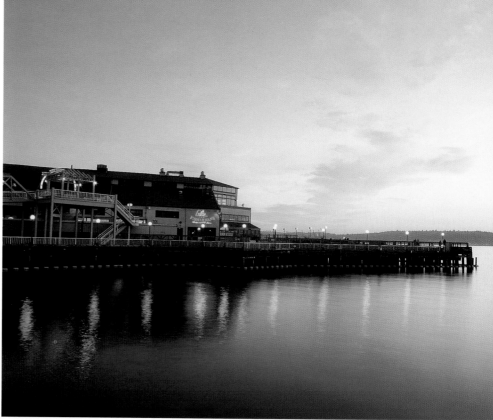

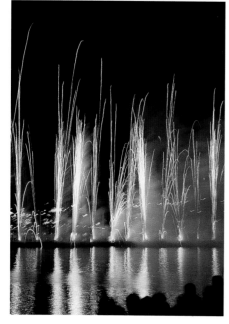

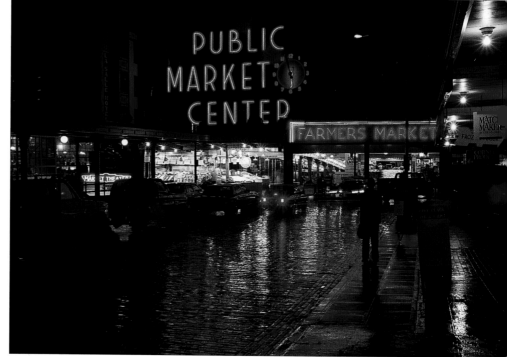

Sunset on the Water

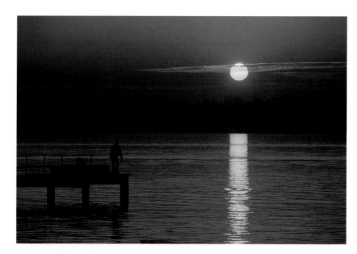

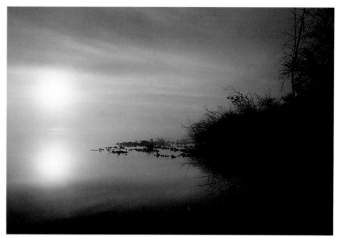

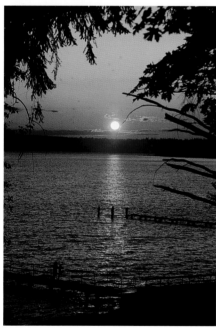

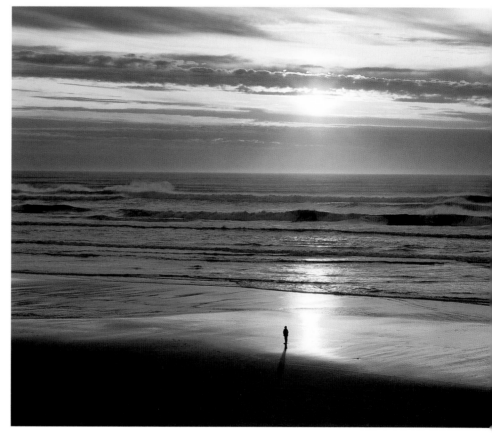

Clouds on the Water

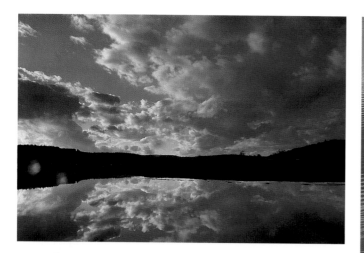

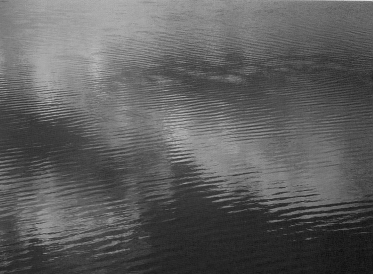

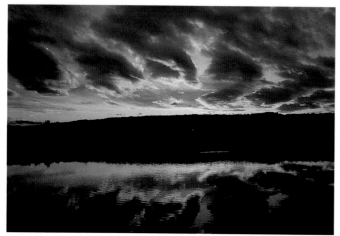

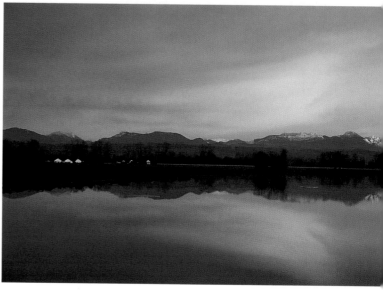

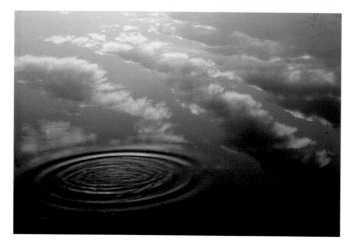

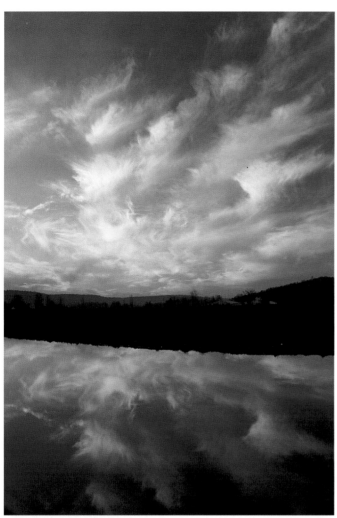

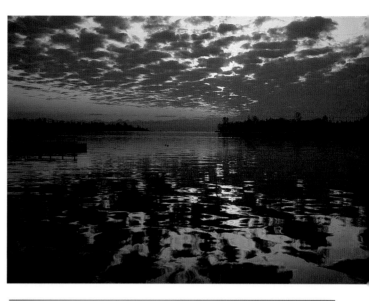

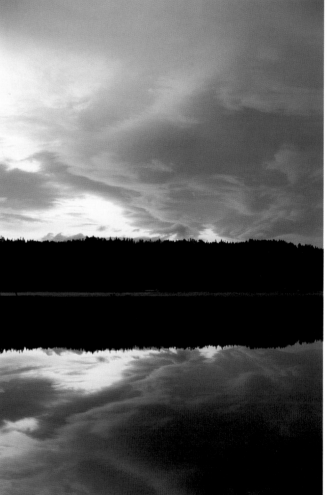

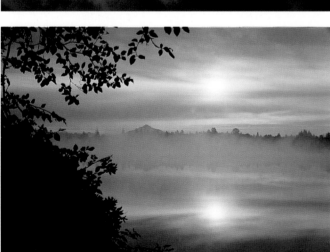

Daylight on Water

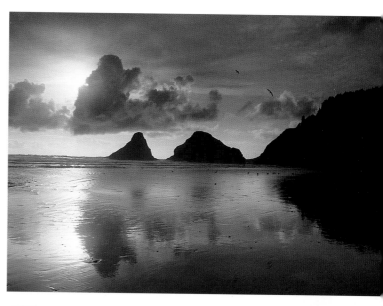

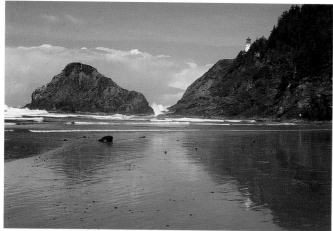

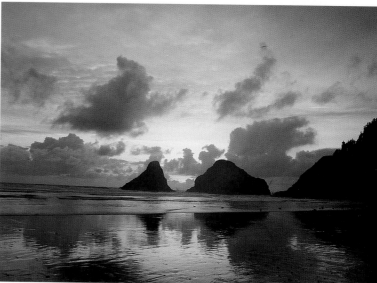

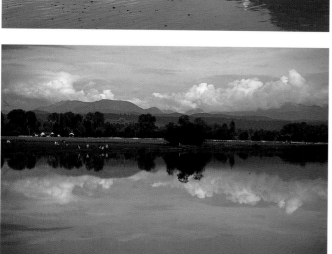

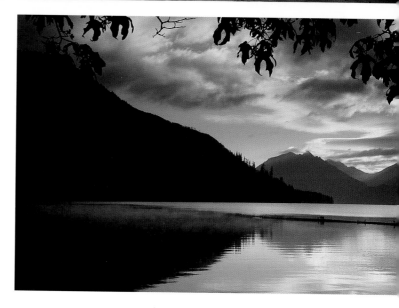

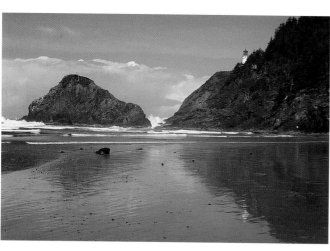

Water Reflections in Motion

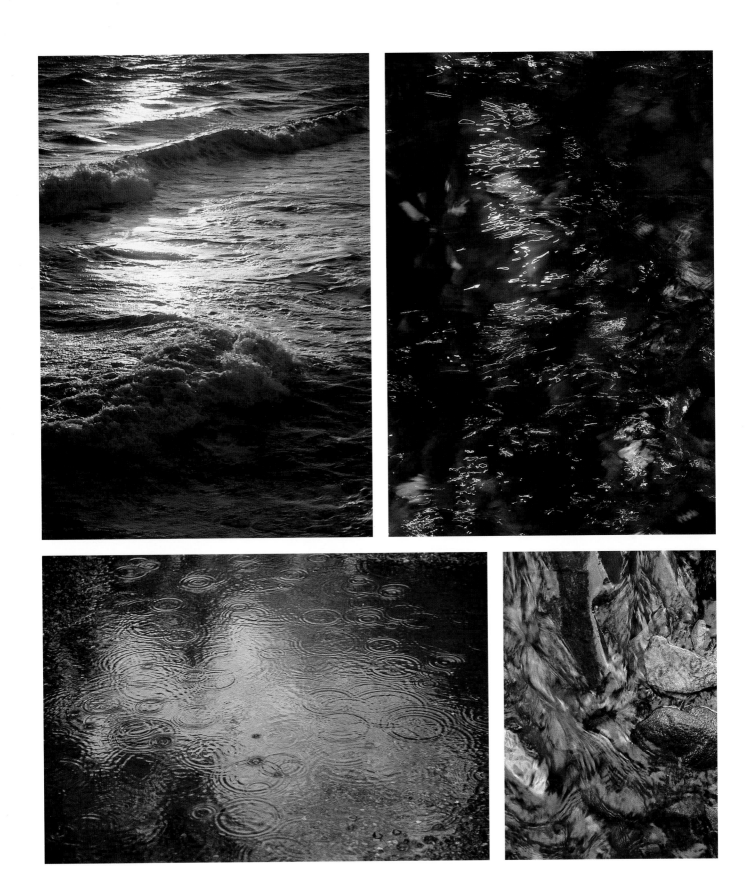

Rippled Reflections

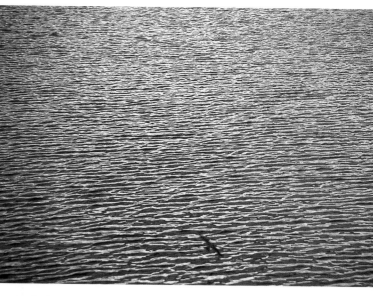

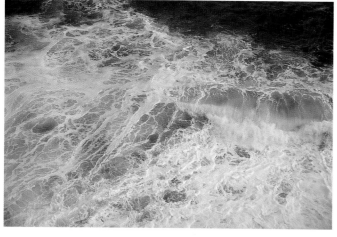

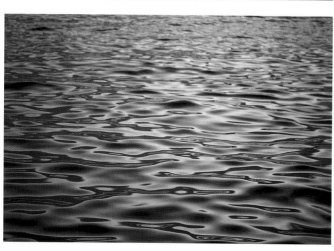

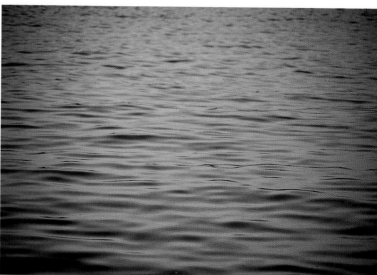

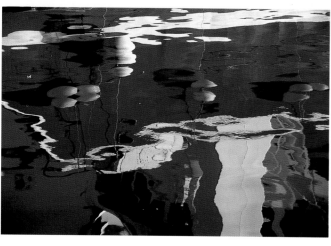

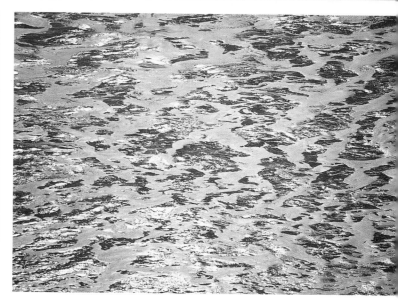

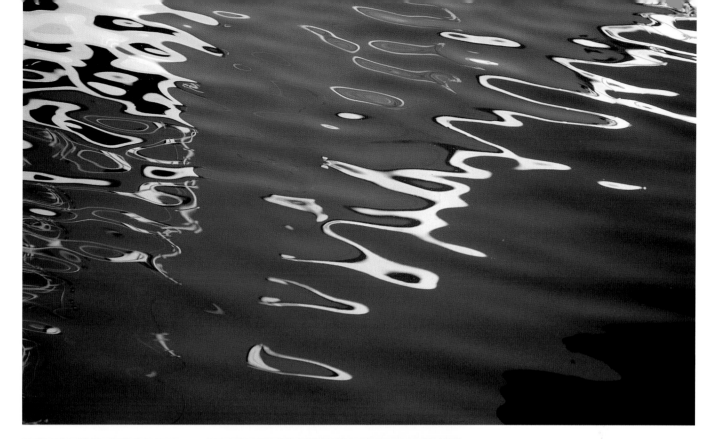

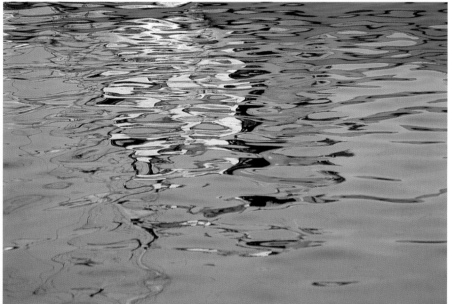

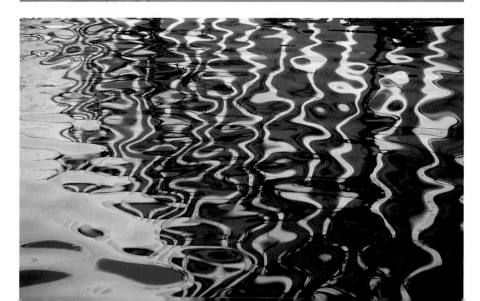

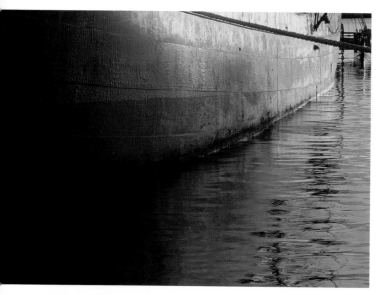

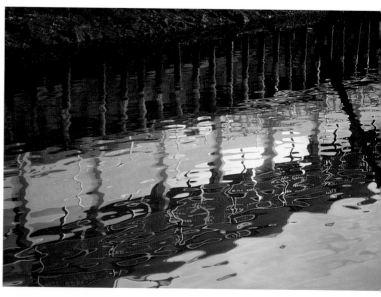

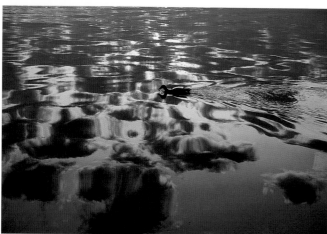

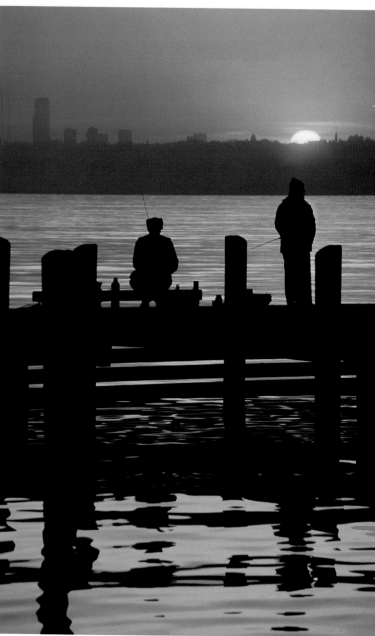

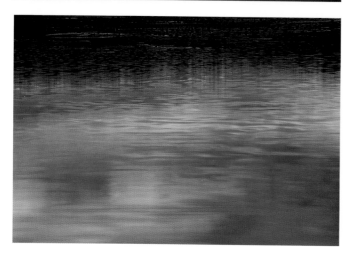

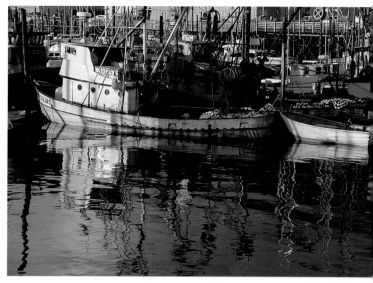

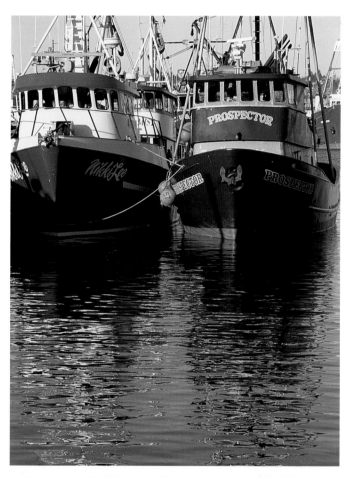

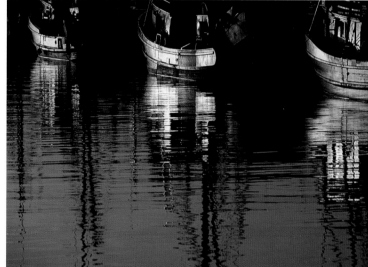

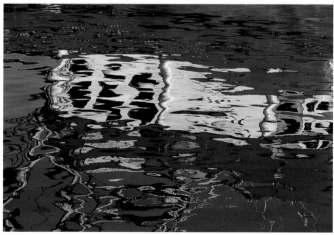

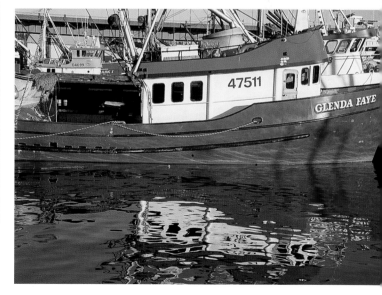

Dew

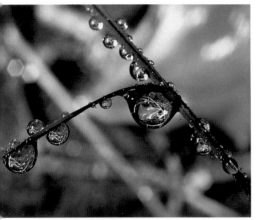

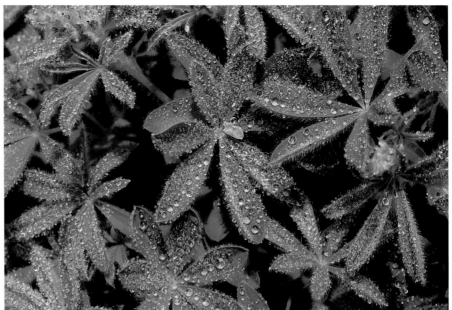

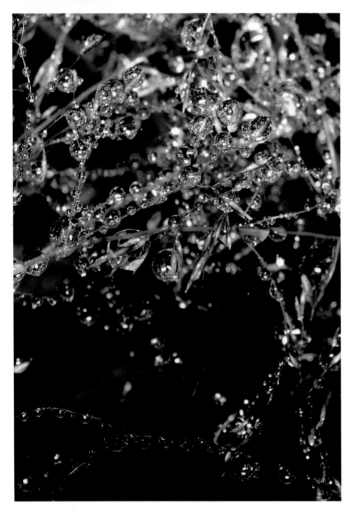

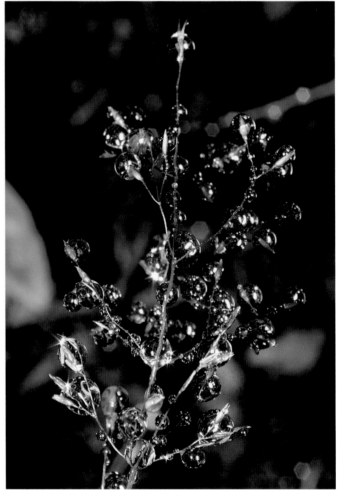

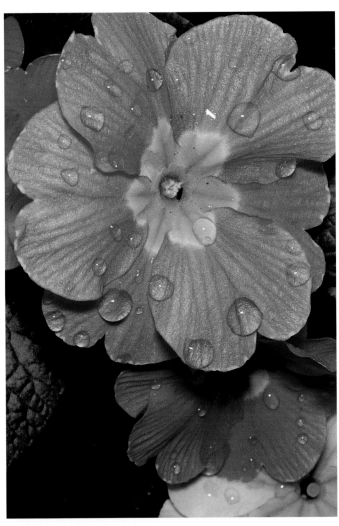

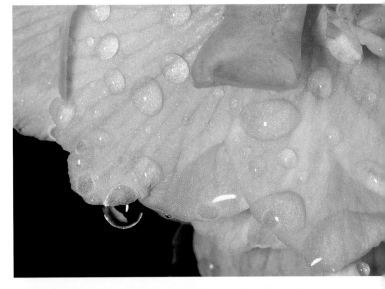

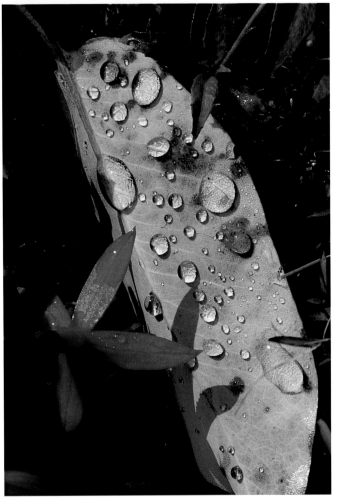

Shore Reflections

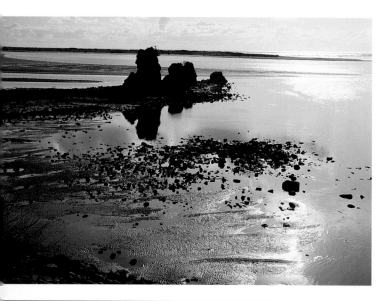

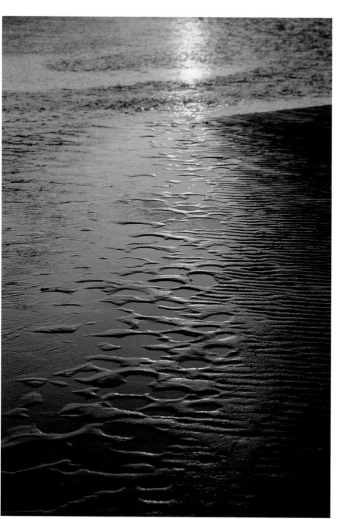

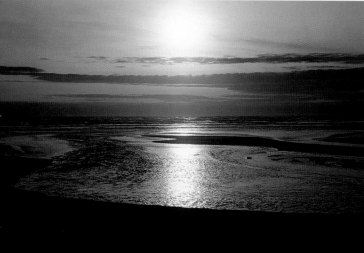

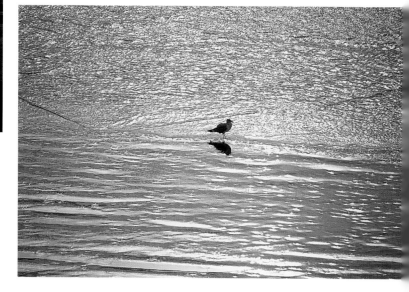

Waterfall Reflections

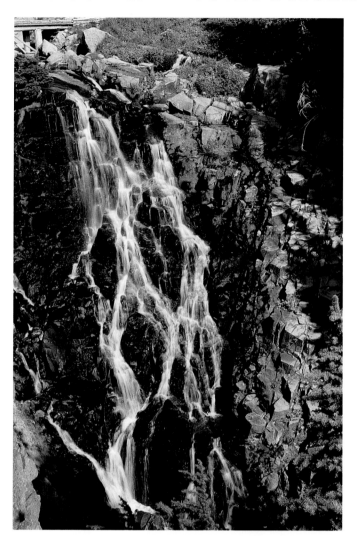

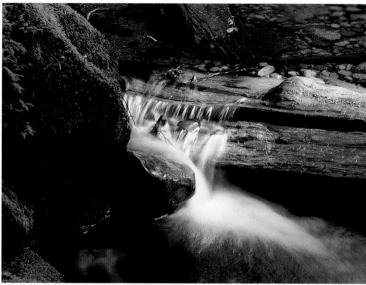

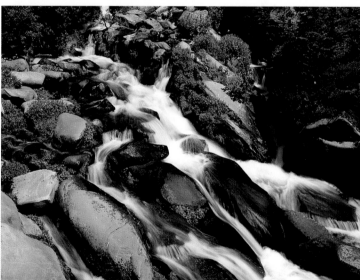

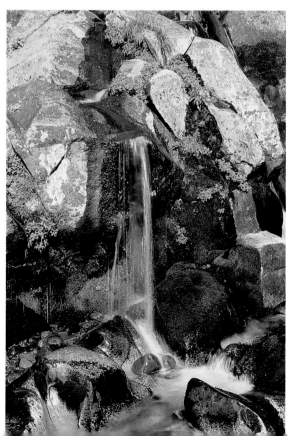

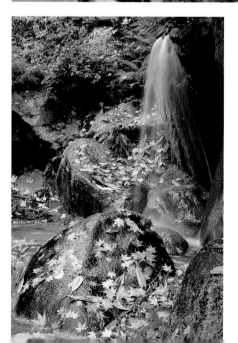

Seasonal Reflections

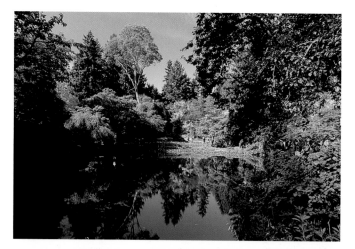

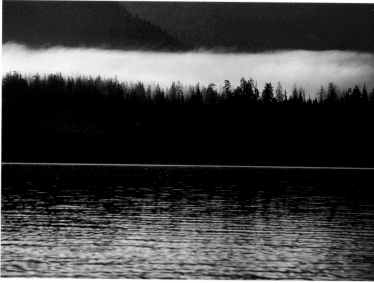

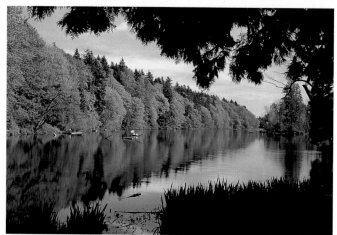

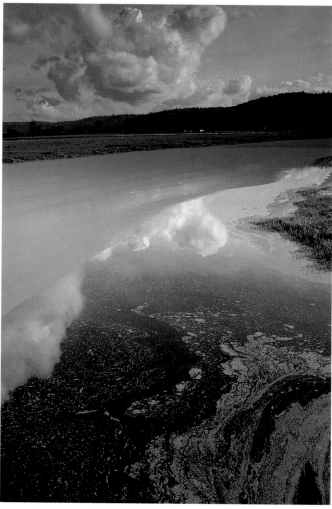

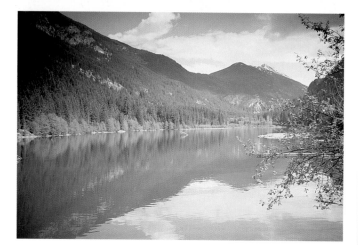

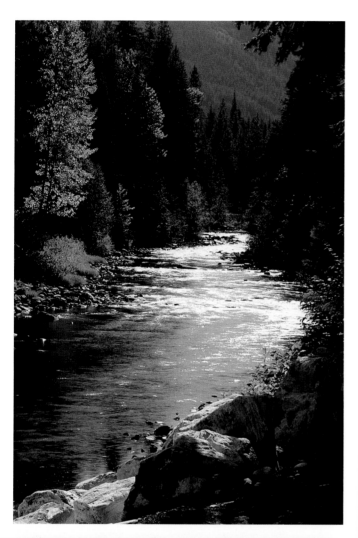

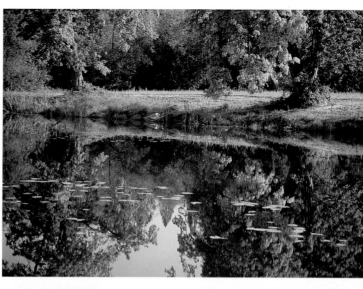

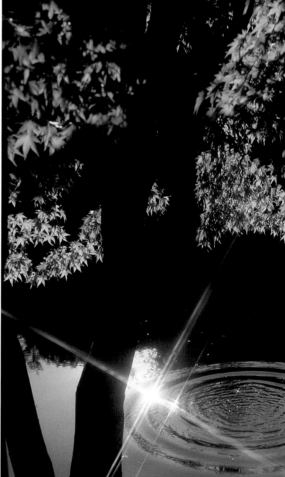

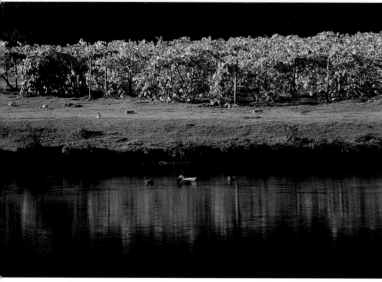

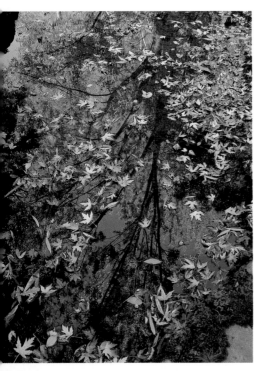

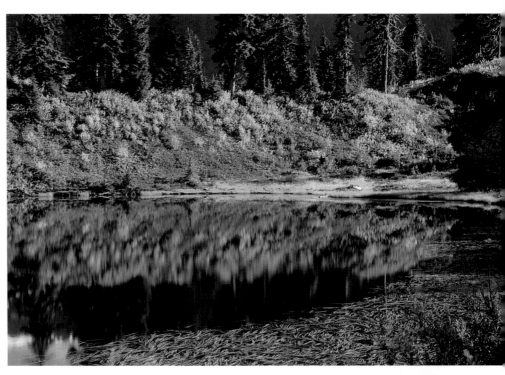

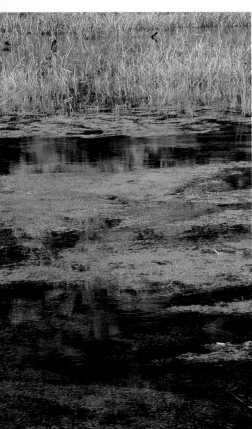

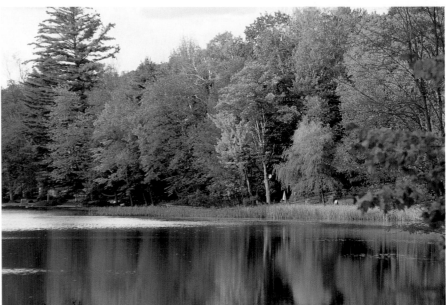

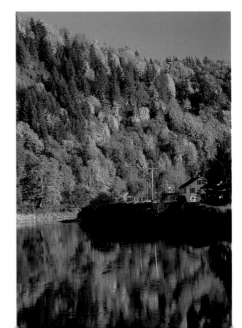

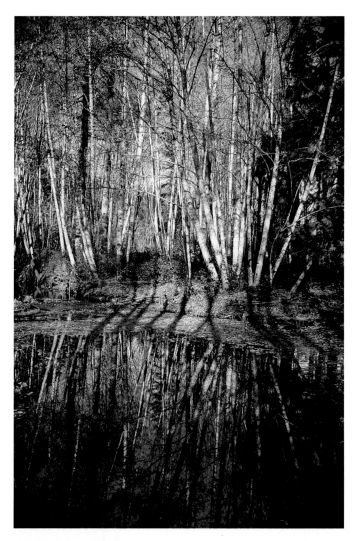

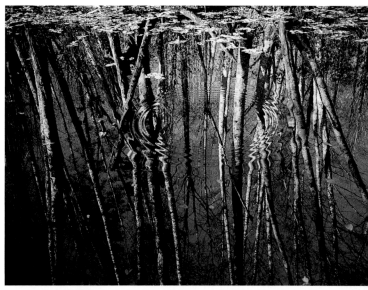

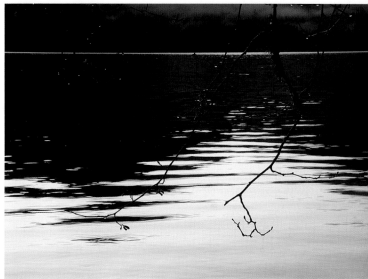

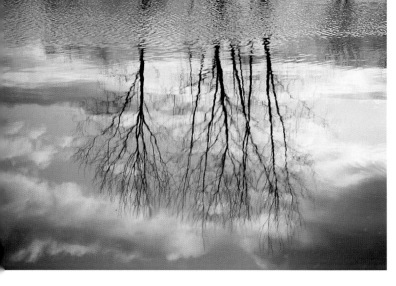

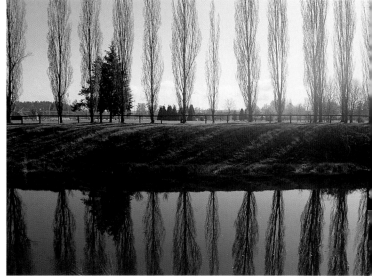

Seattle Reflections

On a clear December day, I was out shooting material for another book, *Artist's Photo Reference: Boats and Nautical Scenes*, when I came across this scene at a local marina. Not only did I find a perfect subject for this book, depicting reflections and the texture of the water, but I also knew who should paint it. With this in mind I knew exactly how to frame the scene, so I took several exposures, resulting in this reference photo, which requires no alteration.

I felt that Beverly's work was so well suited to the subject that I had to invite her to contribute. Having seen her work at a local gallery several months previously, I knew she would create a stunning work for *Artist's Photo Reference: Reflections, Textures & Backgrounds*. Guess I was right!

Materials

Surface
260-lb. (550gsm) cold-pressed watercolor paper

Brushes
Nos. 0, 2, 4, 6 & 8 synthetic rounds
No. 1 flat hog bristle

Color Palette
Daniel Smith Transparent Watercolors
Carbazole Violet, Cobalt Blue, Indanthrone Blue, Manganese Blue Hue, Napthamide Maroon, Phthalo Blue, Quinacridone Burnt Orange, Quinacridone Burnt Scarlet, Quinacridone Coral, Quinacridone Gold, Sepia, Ultramarine Blue

Sanford Prismacolor Colored Pencils
Light Cerulean Blue, Light Umber, Parma Violet, Periwinkle, Sienna Brown, Terra Cotta, Tuscan Red, Warm Gray 50%

Derwent Watercolour Pencil
Blue Gray

Other
Gator board
2-inch (5cm) transparent tape
Opaque projector
Tracing paper
H pencil
Green low-tack tape
Graphite paper
Ballpoint ink pen
White plastic eraser
Waterproof Black India ink
Liquid frisket
Shampoo
Water container
Watercolor palette for mixing paints
Airbrush and compressor
Winsor & Newton Bleed-proof White
Paper towels

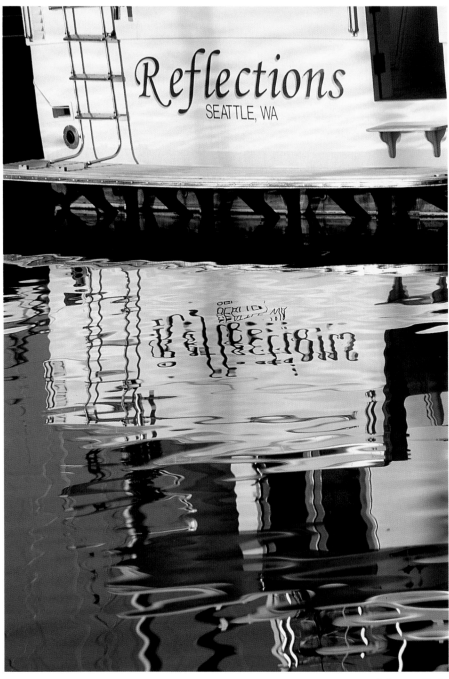

Reference Photo

1. Draw the Layout

Photocopy the original photograph to use as a value study and from which to project the image onto the tracing paper. Once you have determined the overall size of your image, tape the watercolor paper to the Gator board using the 2-inch (5cm) transparent tape. Be careful to retain a border on all sides.

Project the photocopied image onto the tracing paper using the opaque projector. Using an H pencil, draw the image onto the tracing paper.

Position the tracing paper on top of the watercolor paper using the green low-tack tape to hold it in place. Be careful to align the image within the working space you have predetermined within the borders.

Use the graphite paper to transfer the image from the tracing paper onto the watercolor paper. Use the ballpoint pen to draw on top of the pencil lines and transfer the image.

Remove the tracing paper. Smooth out any lines that need adjusting. Use the white plastic eraser to eliminate any smudges or unwanted lines.

2. Fill in the Darkest Areas With Black India Ink

Outline the darkest areas with Black India Ink using a no. 0 brush. Fill these areas in with a no. 4 or no. 8, depending on the size of the area.

Protect the areas you want to keep white—like the rippled vertical lines in the water and the highlighted spots on the stern—with liquid frisket. Begin by dipping the no.1 flat hog bristle brush in the shampoo (this will protect your brush from damage and makes cleaning the brush much easier). Be sure to completely rinse out your brush when finished with this step.

It is essential that the Black India Ink and the liquid frisket be allowed to dry thoroughly before beginning any further steps. Never use a hair dryer to force dry the liquid frisket.

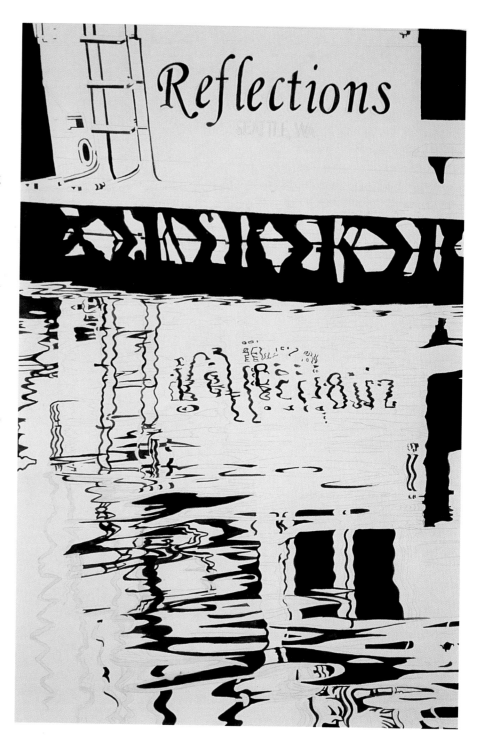

3. Paint the Underlying Washes

Wet the surface of your work area with clear water to begin the process of layering overall washes using Manganese Blue Hue, Indanthrone Blue, Phthalo Blue and Ultramarine. Start at the bottom with the darkest blue—Indanthrone Blue—and then work from the darkest to the lightest color blues using a no. 12 brush. Working wet into wet allows you to blend the entire range of blues with a series of parallel soft strokes. The result is in a mirror-like quality to the water's surface.

Paint very light wet washes onto the stern of the boat. Use the Quinacridone Burnt Orange, Quinacridone Burnt Scarlet, Quinacridone Gold, Carbazole Violet and Cobalt Blue. Apply these colors to the wet surface and blend them into a very thin glaze of color. Paint the reflection of the boat with matching thin glazes, working wet into wet.

After the washes are thoroughly dry, use the no. 6 brush to bring the first layer of color into the lower third of the painting with Quinacridone Gold, Quinacridone Burnt Orange, Quinacridone Burnt Scarlet, Cobalt Blue and Quinacridone Coral.

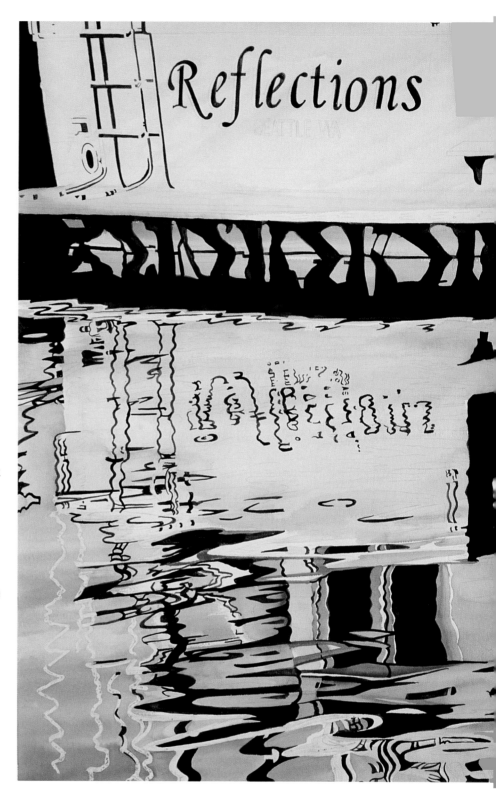

4. Paint the Second Wash Layers and Preliminary Detail

To create various shades of brown in the boat's reflection, combine the Quinacridone Burnt Orange with the Carbazole Violet. The ripples are actually very small graded washes. Blend the color into a hard-edged oval with a no. 4 brush, then touch a wet no. 6 brush to the center of the oval to dilute the pigment.

With a no. 2 round brush, add detail to the ladder and the swimmer's deck by layering Cobalt Blue, Indanthrone Blue, Carbazole Violet and Quinacridone Burnt Orange into the shadowed area under the stern of the boat. Use the airbrush to darken the blue water with a combination of Indanthrone Blue, Carbazole Violet and Cobalt Blue.

After this is complete, return to the reflections on the water. Add more color with a no. 2 brush, concentrating initially on the reddish highlights using Quinacridone Coral and Quinacridone Burnt Scarlet.

For the darker portion of the painting—the ripples in the lower right—add layers of color using the full range of blues and violets from the palette with the no. 4 and no. 6 round brushes. This results in a richness of color impossible to create without layering multiple hues over each other. Use a thin glaze of Cobalt Blue, Carbazole Violet and Indanthrone Blue over the Quinacridone Gold, Quinacridone Burnt Orange and Quinacridone Burnt Scarlet.

Next, add reddish accent color to the boat's reflection using Quinacridone Coral with a no. 0 brush.

Look at the reference photo and you'll see that the word "Reflections" has a shadow to give the word relief. To paint this, lay in hard-edged color along the lettering using a no. 0 brush. Dip the no. 2 brush in clear water and then stroke the brush parallel to the lettering

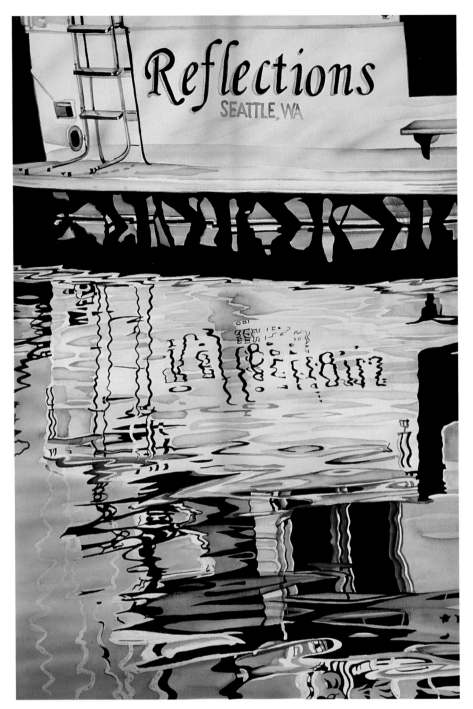

to create a faded wash. The colors used include Quinacridone Gold, Cobalt Blue, Carbazole Violet, Quinacridone Burnt Orange and Quinacridone Burnt Scarlet.

Using a no. 2 brush, paint in the words "SEATTLE, WA" on the stern using a mixture of Quinacridone Burnt Scarlet, Indanthrone Blue and Napthamide Maroon. Blend the paint into a graded wash, the lighter shades at the bottom

of the letters and the darker shades at top.

Mix Carbazole Violet and Quinacridone Burnt Scarlet into a very diluted solution with clear water for use in the airbrush. Using the airbrush, apply a very light glaze over the central vertical region of the painting through the "flec" and "SEATT" lettering down into the reflection of the vessel.

5. Add the Final Details

Remove the frisket that has been protecting the white areas. Now paint these areas with a combination of Indanthrone Blue and Napthamide Maroon, with just a touch of Quinacridone Burnt Orange.

Lay in the dark gray areas hidden in shadow under the swimmer's platform of the boat using a no.4 brush. Use colors darker than you want—like Carbazole Violet, Cobalt Blue, Indanthrone Blue and Naphthamide Maroon—to layer the ripples toward the bottom of the painting, then remove much of the pigment with a stroke of clear water. Detail the swimmer's deck using Carbazole Violet, Cobalt Blue, Quinacridone Burnt Orange, Quinacridone Burnt Scarlet and Sepia. With a no. 4 brush, create a hard line blended to a graded wash.

At this stage, bring in the colored pencils to detail the black, inked-in areas. Beginning in the upper right corner of the painting, apply Derwent Blue Gray Watercolour Pencil and the Prismacolor Periwinkle and Parma Violet pencils to lighten the details of this shadowed area. The addition of color also softens the solid black areas.

Use the Prismacolor Parma Violet and Sienna Brown to render the detail on the step bracket. For the area under the swimmer's platform, use Prismacolor Sienna Brown, Terra Cotta, Tuscan Red, Warm Gray 50%, Light Cerulean Blue and Light Umber pencils. Repeat these color combinations in the reflections.

In the photo, more of the boat is revealed in the reflection. Use all of the colored pencils and the watercolor pencils listed in the materials list to create the reflection of the cabin and the superstructure. Blend each individual area into combinations of color that fade from dark to light.

To create the bright highlights, use the Winsor & Newton Bleed-proof White in small dots and areas throughout the water surface, and in the center

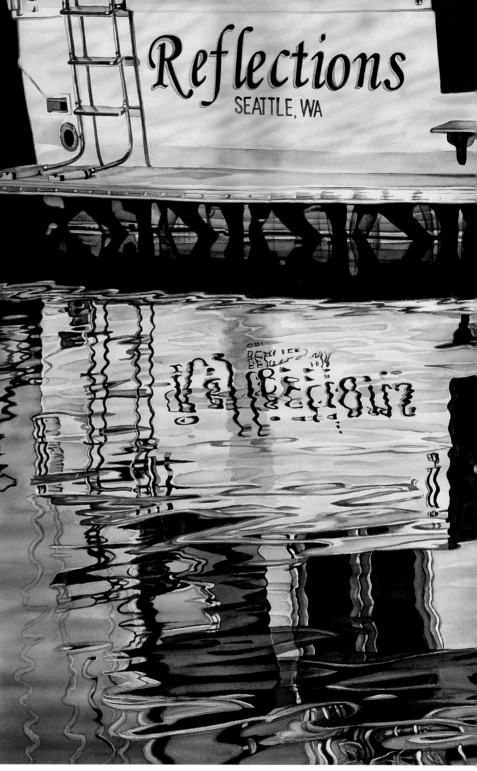

Seattle Reflections
Beverly Fotheringham
25" × 17" (64cm × 43cm)
Mixed water media on 260-lb. (550gsm)
cold-pressed watercolor paper

few inches of the line that stretches across the stern of the boat.

To finish the painting, use a no. 1 flat hog bristle brush dampened with clear water to remove pigment in selected

locations, such as the stern of the boat. Scrub out the color and then blot up the moisture using paper towels. This reductive technique provides a very realistic sheen to the reflective surfaces.

Classic Car Reflections

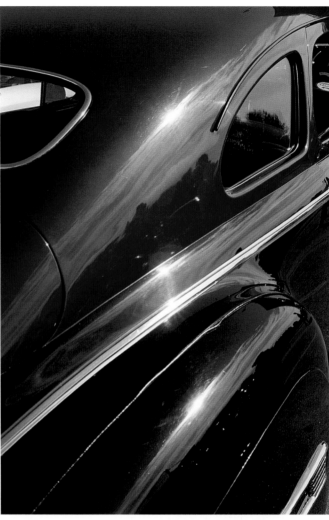

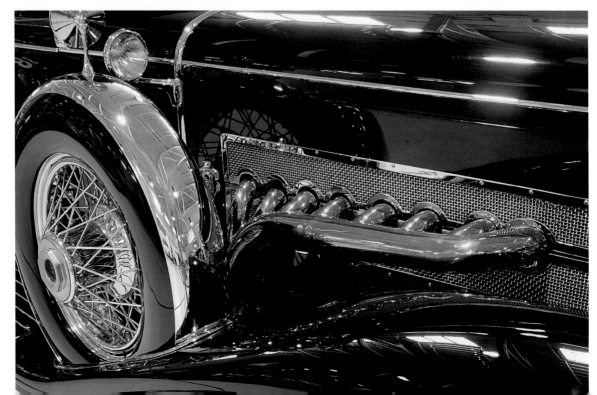

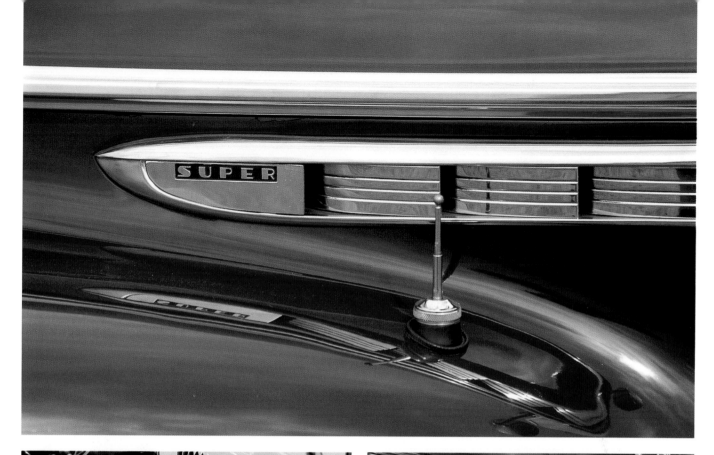

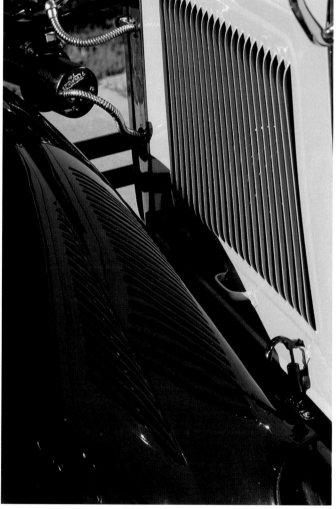

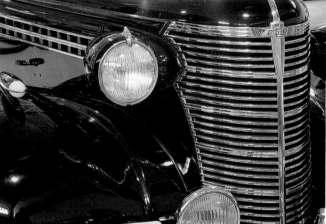

Reflections in Metal

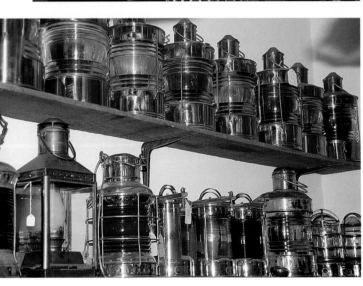

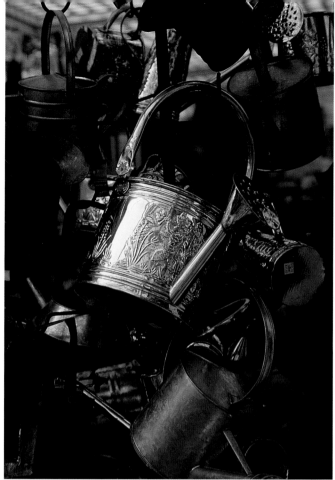

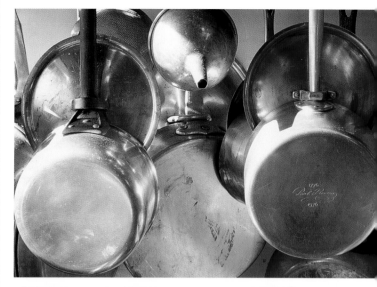

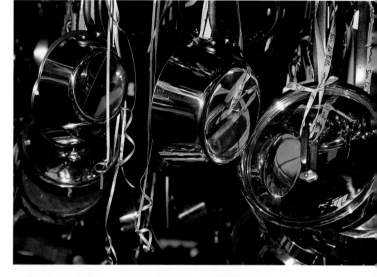

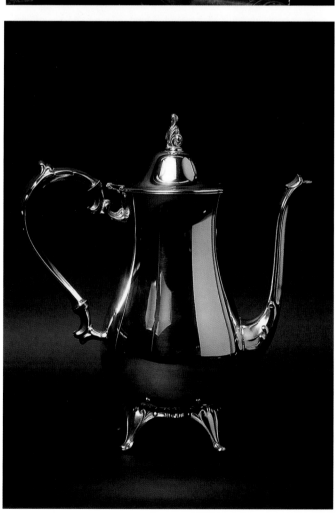

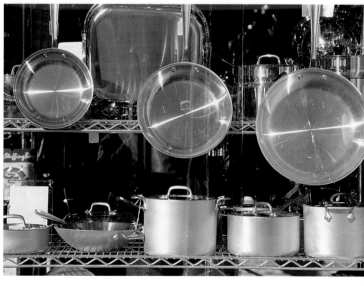

Reflections in Glass

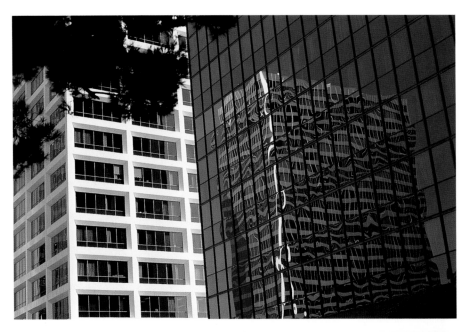

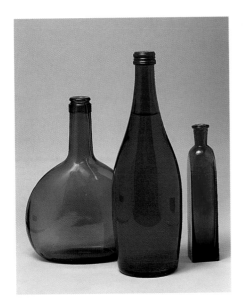

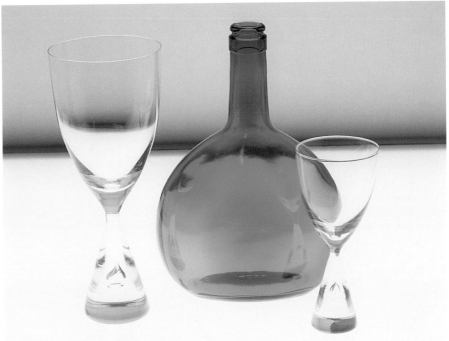

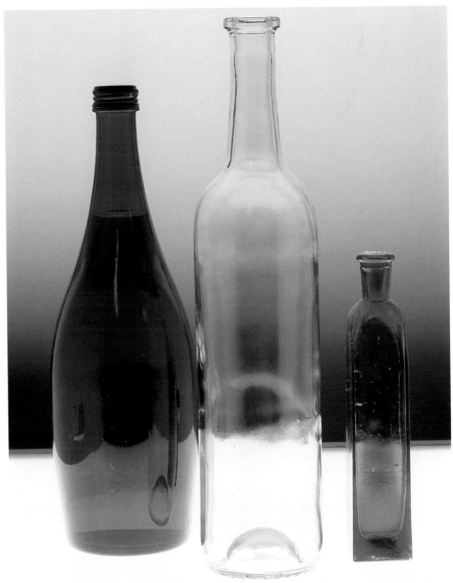

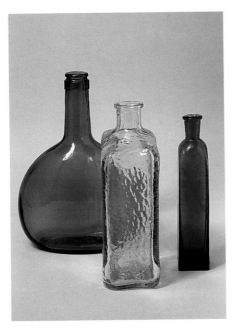

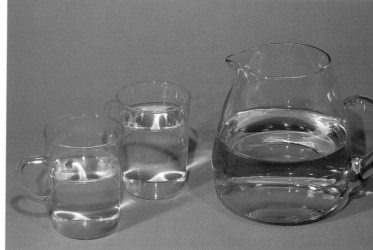

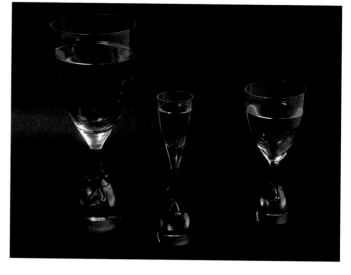

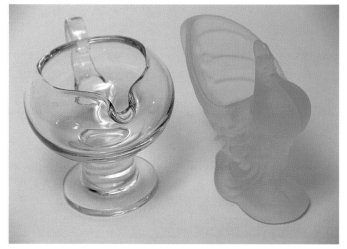

Memories

Materials

Surface
18" × 24" (46cm × 61cm) 140-lb.
 (300gsm) Arches watercolor paper
18" × 24" (46cm × 61cm) 100% rag draft-
 ing paper
18" × 24" (46cm × 61cm) graphite trans-
 fer paper

Brushes
No. 16 round brush
No. 4 round brush for details
2-inch (51mm) Japanese Hake brush for
 area wetting

Color Palette
Winsor & Newton Artists' Water Colours
Alizarin Crimson, Burnt Orange,
Cadmium Red, Cobalt Blue, Indigo,
Permanent Rose, Raw Sienna, French
Ultramarine, Winsor Green

Holbein Artists' Water Color
Jaune Brilliant #2

Caran D'Ache colored pencils
Dark Green, Indigo, Purple Rose, Raw
Sienna, Red

Sanford Prismacolor colored pencils
White

Other
HB graphite pencil
Tombo ABT N25 black pen/brush
Golden gesso (white)
Golden polymer gell (gloss)
Water container
Paper towels
Elephant Ear sponge
4 bulldog clips
Gator board cut 1-inch (3cm) larger all
 around the watercolor paper

One of my favorite places for shoot-
ing reference photos is the historic
old town of Port Townsend,
Washington. On a recent visit, I took a
tour of the Rothschild House, one of the
many faithfully restored homes.

Taking advantage of the soft natural
light, I placed my camera on a tripod
and photographed this "found" still life,
among several other prime reference
photos. With careful cropping and the
omission of some unnecessary details,
such as the busy wallpaper, talented
artist Pia Messina turned the scene into
an exciting impressionistic artwork, cre-
atively using a number of mediums.

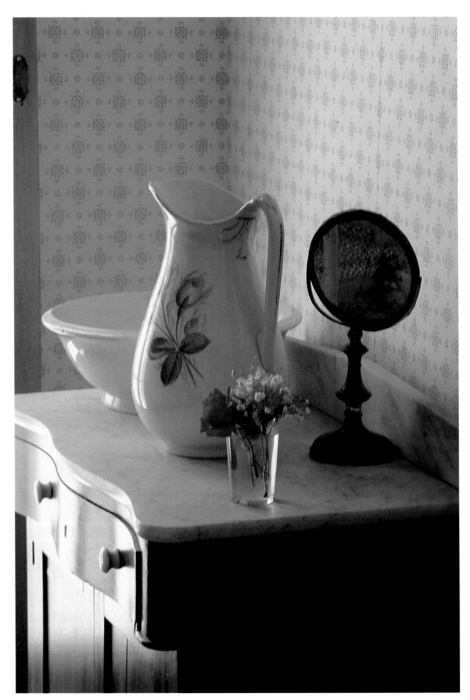

Reference Photo

1. Draw the Layout

Photocopy the reference photo.
Draw a grid on the photocopy with the
Prismacolor White colored pencil. With
the HB graphite pencil, draw a grid on
the drafting paper proportional to the
one on the photocopy. Use the grids to
compare as you draw an enlarged image
of the subject on the drafting paper.

Lay the graphite transfer paper on
the watercolor paper, and then lay the
drafting paper on top. Go over the
image on the drafting paper with the
graphite pencil, pressing lightly so that
the image is duplicated on the water-
color paper.

2. Underpaint the Middle Values

Clip the watercolor paper to the Gator
board with bulldog clips. Tilt the board
at a 30° angle. With the Elephant Ear
sponge, wet the paper a few times to
remove the paper's protective sizing.
Let dry.

Lay a coat of white gesso with random
strokes to emphasize texture. Let dry.

Lay a wash of Cobalt Blue with a
touch of Burnt Orange on all middle
value areas using the Hake brush. Be
careful to save the highlighted areas.
Let dry. Paint a thin wash of Golden gel
diluted 50 percent with water and then
allow it to dry. The wash of Golden gel
will make the paper a little slippery, so
corrections will be easier.

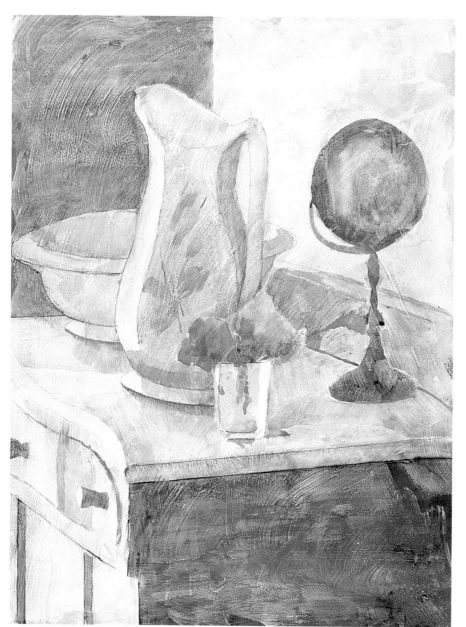

3. Add Darker Values

Lay a wash of Cobalt Blue and Burnt Orange on the background areas, the pitcher's side and handle, and the mirror. Using the same wash with a little Indigo added, darken the contour of all the objects' bases and the rims with a no. 16 round brush. Paint the front area of the marble top with Permanent Rose and Raw Sienna. Leave the reflecting areas on the pitcher and glass white. Paint the shadowed areas on the marble top Permanent Rose, Raw Sienna and Ultramarine Blue. Wet the wood on the side of the dresser lightly with the Hake brush, then paint it with Permanent Rose, Raw Sienna, Ultramarine Blue and Indigo. With a mixture of Ultramarine Blue, Burnt Orange and Alizarin Crimson, paint the mirror stand. Let dry.

Paint the two flowers, one Cadmium Red and the other Permanent Rose. Paint a flower on the pitcher with Alazarin Crimson, Winsor Green and Raw Sienna. Paint the drawer knobs and cabinets. Let dry.

4. Add Details

Paint a wash of Jaune Brilliant #2 on the lighter portion of the wall and then do the same on the front of the dresser. Let dry.

Color dark areas of both flowers with Alizarin Crimson. To emphasize the rose stems between the flowers, use the Dark Green colored pencil. Accent the lighter leaves with Raw Sienna watercolor.

On the mirror, detail the reflections of the pitcher handle and some red color from the flowers with colored pencils. Add texture to marble in the back with Indigo colored pencil. When everything is completely dry, outline all the shapes with the black pen to convey a feeling of the human touch.

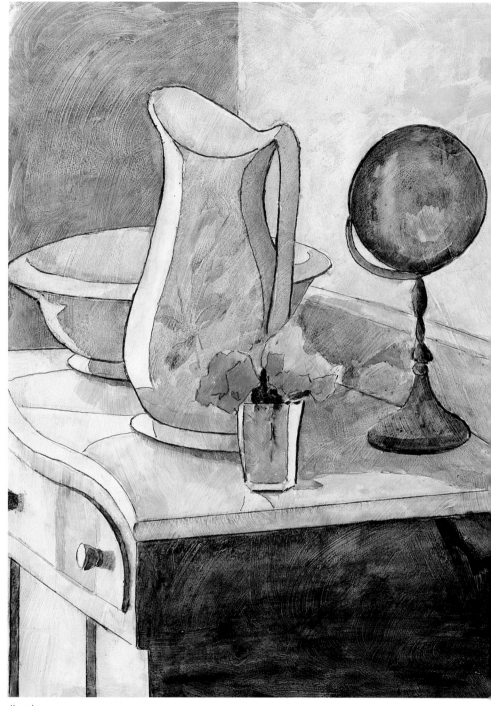

Memories
Pia Messina
24" × 18" (61cm × 46cm)
Mixed Media

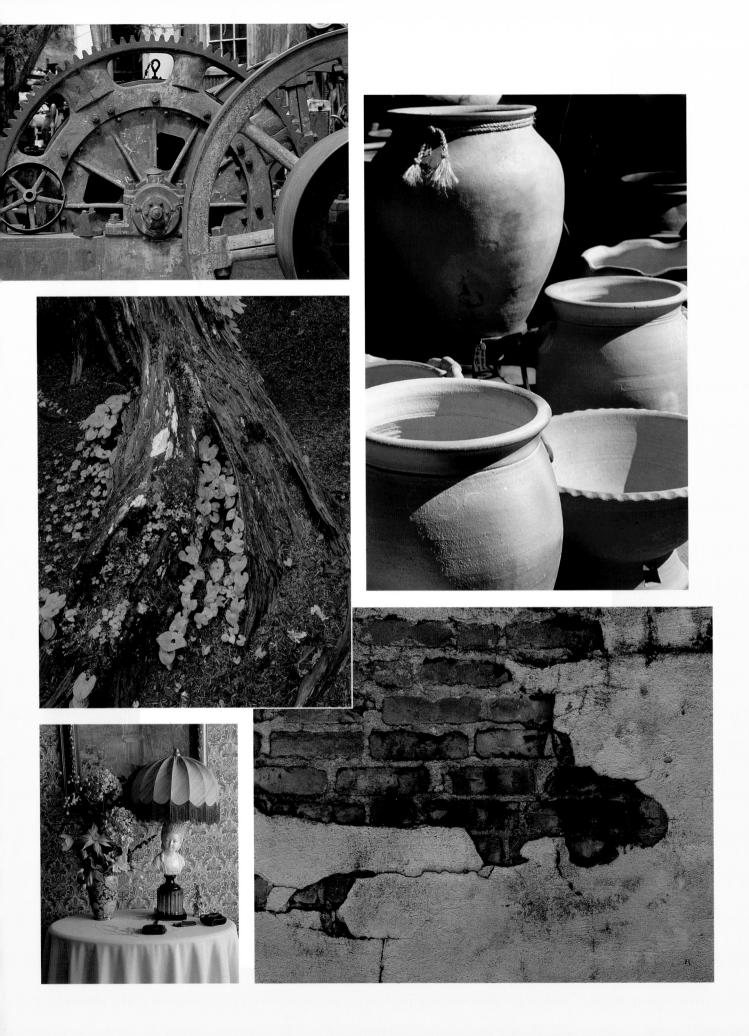

CHAPTER 2

Textures

Everything has a texture. From smooth paper to rough splintery wood, from glistening polished metal to fleecy white clouds... textures are everywhere. Regardless of style, medium or level of expertise, artists need to study the textures of their subjects to complete their work successfully.

Of course, every texture cannot be included here, but we have attempted to provide textures, both natural and man-made, that are useful to the artist.

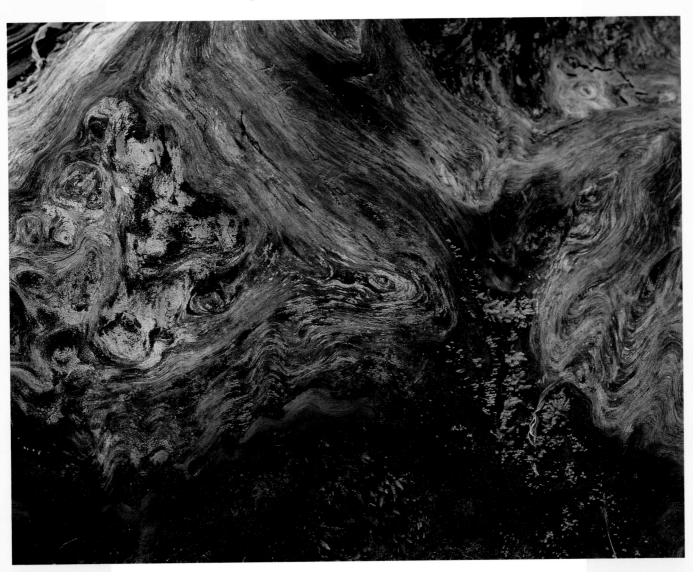

Tree Bark Textures

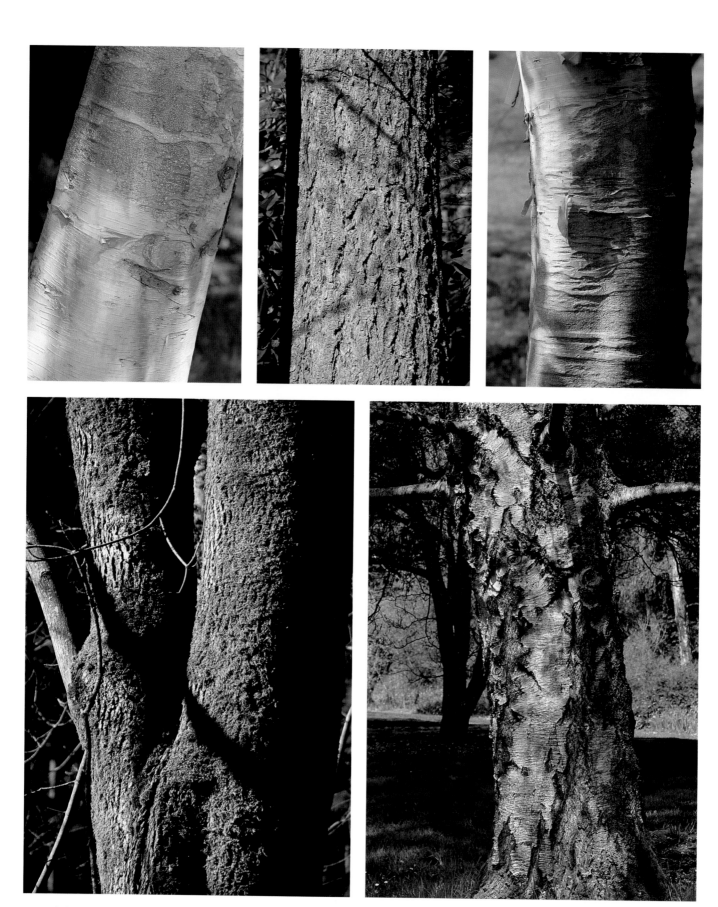

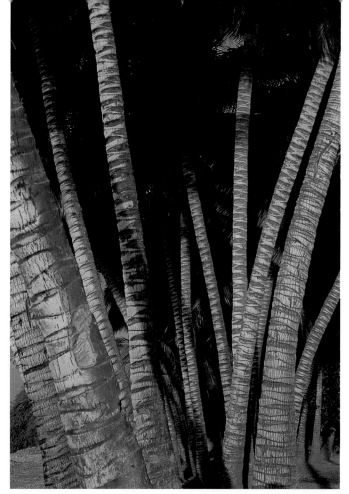

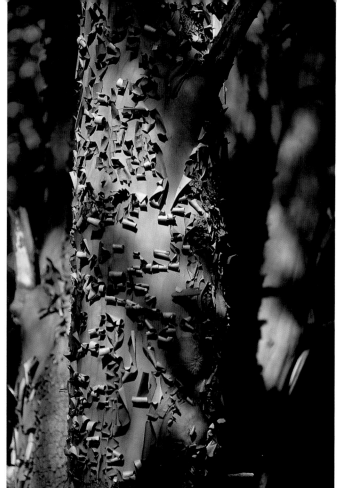

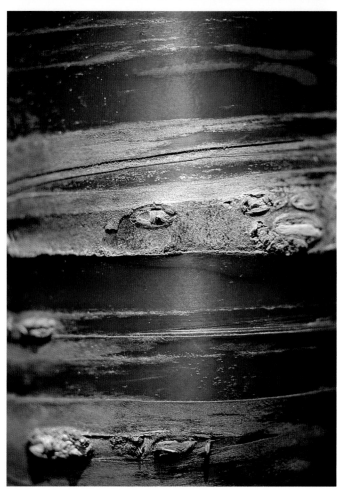

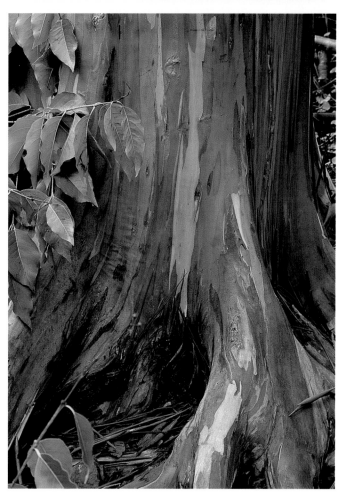

Wood Textures

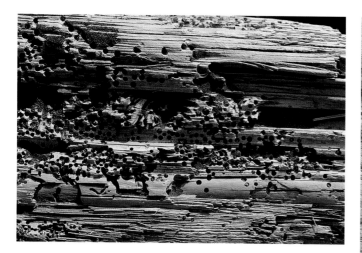

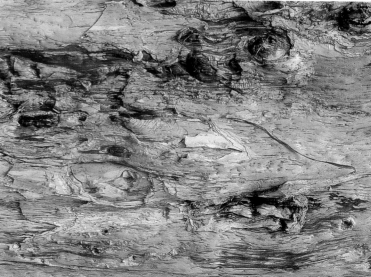

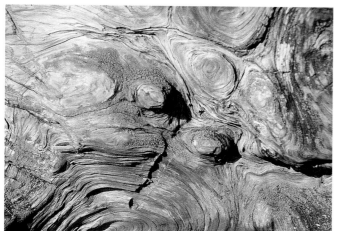

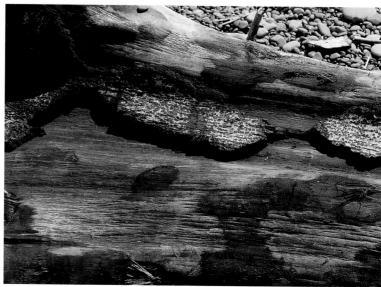

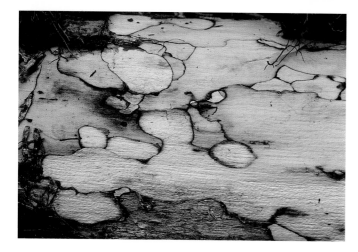

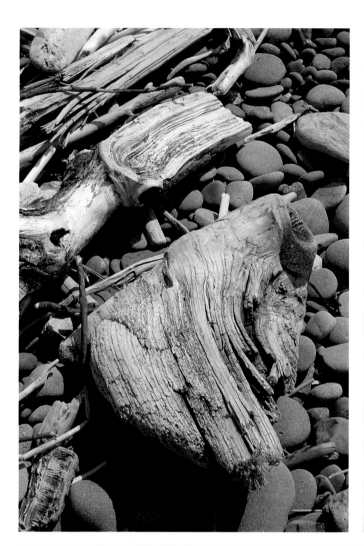

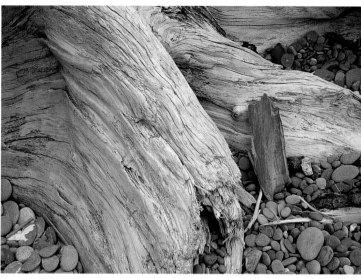

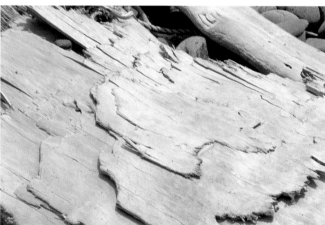

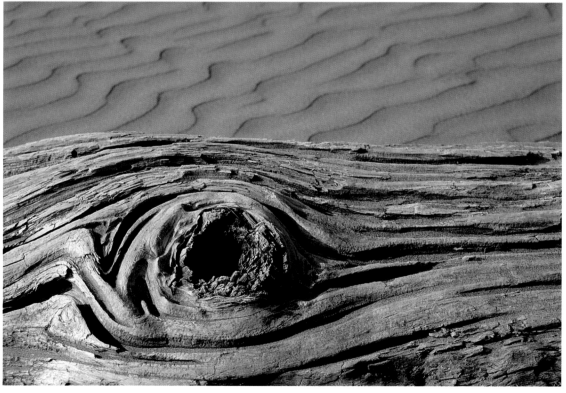

Final Resting

Materials

Surface
18" × 24" (46cm × 61cm) Fredrix canvas panel

Brushes
Nos. 2, 6 & 8 natural white bristle filberts

No. 4 sable round

⅛-inch (3mm) badger flat

2-inch (51mm) house paintbrush (for applying gesso)

Color Palette
Winsor & Newton Griffin Alkyd fast-drying oil paint
Burnt Sienna, Cadmium Red Light, Cadmium Yellow Deep, Cadmium Yellow Light, French Ultramarine Blue, Permanent Alizarin Crimson, Phthalo Blue, Titanium White

Other
Daniel Smith Venetian Red Acrylic Gesso

Stick of white chalk

Odorless Turpenoid

Winsor & Newton Liquin for oil and alkyd

Paper towels

Paint palette (paper, glass or enamel)

Palette mixing knife

Krylon Kamar spray varnish

In this great painting by Liana Bennett lies a tale of two national parks: the image of the burled tree trunk was made in Olympic National Park and the mountain lupine in Rainier National Park, both in Washington.

The burled trunk presents a fascinating texture study but the surroundings are banal. To liven the scene, the lupine was added from the other reference photo by both cutting and pasting and using the cloning tool in Photoshop. Although the process was a bit time consuming, the resulting reference photo made a considerable improvement over the original.

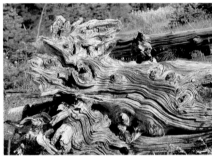
Reference Photo

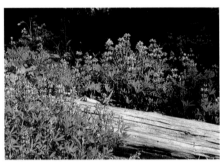
Reference Photo

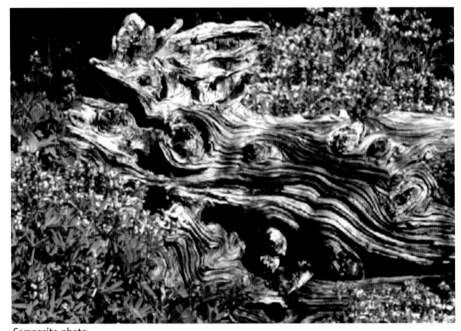
Composite photo

Helpful Hints for Using Alkyds
- Store alkyds in a cold place, such as a refrigerator or freezer.
- Any medium that is used for standard oils can be used with alkyds, but media such as linseed oil will retard drying time.
- To accelerate the drying time, place your painting in a warm area.

1. Sketch the Layout

Use a standard house paintbrush to apply a single coat of red gesso to the canvas panel. Let dry.

Sketch a few preliminary drawings before chalking the final layout on to the gessoed canvas. Keep the lines and shapes loose and abstract.

2. Block in Shapes

Once this is complete, prepare your paints. Mix French Ultramarine Blue and Burnt Sienna to create a black that can be changed to a warm or cool color.

Block in various shapes and values using Liquin and Odorless Turpenoid to thin and lighten the color.

In addition to the black mix, you will need to create a purple mixture and a white mixture. For the purple, combine Alizarin Crimson, French Ultramarine Blue and a touch of Cadmium Yellow Deep. The white mix should consist mostly of Titanium White with light touches of French Ultramarine Blue, Alizarin Crimson and Cadmium Yellow Deep.

3. Paint the Background, Define the Wood

Using your no. 8 filbert brush and the black mix, add just enough Cadmium Yellow Light to make a deep green. Cover the area under the green leaves with this deep green. Add Titanium White and more Cadmium Yellow Light to suggest leaves and stems.

Next, use the purple mixture with a touch of Titanium White under the flower areas. Add more Titanium White to enhance the light on the flowers.

For the darkest shapes and lines in the wood, use the no. 4 round brush and the black mix. Be sure to find the "movement" in the wood. Is it straight? Curved? Swirled? Thick or thin? Spread your paint thickly for dark shapes.

Using the same brush and the white mix, paint the lightest areas of the wood. Add touches of purple mix to the white mix to create middle to light values in the wood. Now the painting has values ranging from the darkest to the lightest. You can now compare all the other color values to these high contrasting hues.

4. Detail the Wood, Background Flowers and Leaves

To add fullness to the flowers, pick a brush that matches the strokes you need. Use the purple mixture to paint the flowers, adding Titanium White, Permanent Alizarin Crimson or French Ultramarine Blue to change the hue to pink or blue. This will add variety and depth to the flowers.

For the leaves in the background, use the black mix as the base. You can add more Cadmium Yellow Light, Titanium White, Phthalo Blue or French Ultramarine Blue as necessary to give several green hues to the leaves, but be sure to leave some dark hues to create depth.

Look for warm areas on the wood, using Burnt Sienna and a no. 2 round

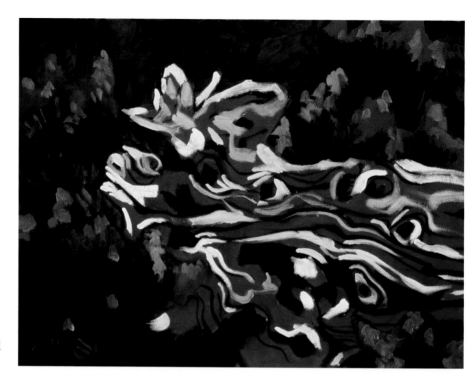

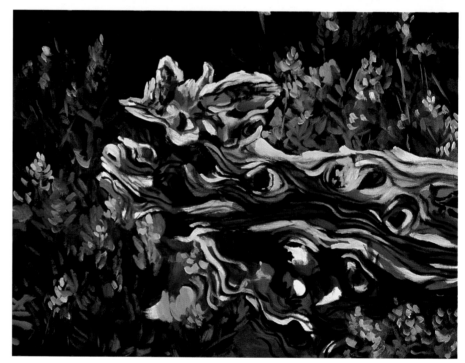

brush to note these areas. Next, to tone down and lighten the purple mix, add the white mix. Place this color between the dark lines. It's OK if some blending occurs. Add more detail to the wood with the ⅛-inch (3mm) badger flat and black paint mix. Adjust black shapes in the wood if necessary.

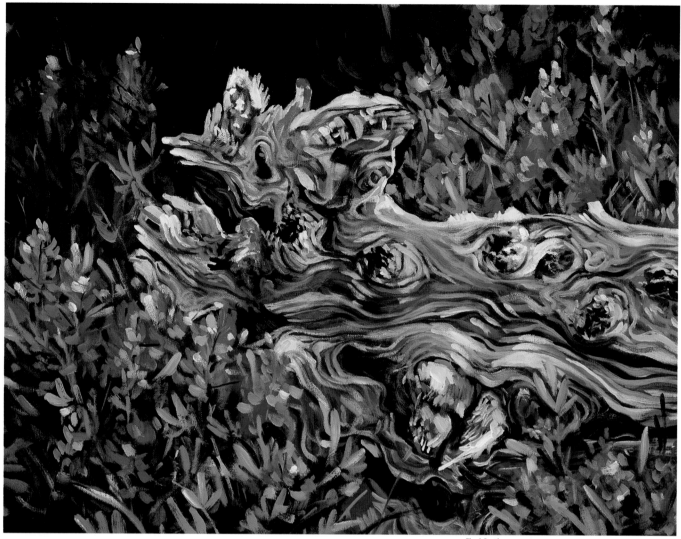

Final Resting
by Liana Bennett
18" × 24" (46cm × 61cm)
Alkyd oil on canvas board

5. Add the Finishing Touches

Starting in the area behind the wood, use the purple mix to add smaller shapes and lighter values to the flowers with the ⅛-inch badger flat or the no. 4 round brush. Keep the stronger lights on top and vary the hues to create a more natural look. Use more French Ultramarine Blue, Permanent Alizarin Crimson or Titanium White as necessary.

To highlight the leaves, add Cadmium Yellow Light and Titanium White with the black mix. Change the hue of the black mix by adding Cadmium Yellow Light, Cadmium Red Light, Phthalo Blue or Titanium White to add variety to the greens for the leaves and stems.

Before finishing the wood, mix together two new colors—blue-gray (mix Titanium White with the black mix) and soft gray (add Titanium White and a touch of Cadmium Yellow Deep with the purple mix). Add touches of Burnt Sienna or Cadmium Red Light to the white mix to create a wide range of colors in which to finish your wood.

Use a detail brush to add small areas of detail, such as the protruding nubs of wood. Blend some areas and leave others sharp to add extra dimension.

Wait 24 hours to dry. After your painting is dry, apply two thin coats of Krylon Kamar Spray Varnish in a well-ventilated room.

Mosses and Lichens

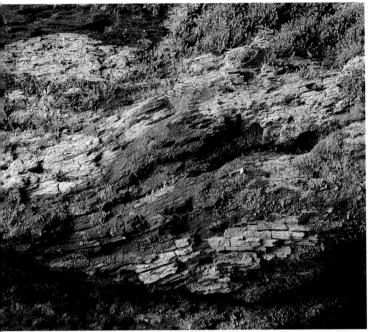

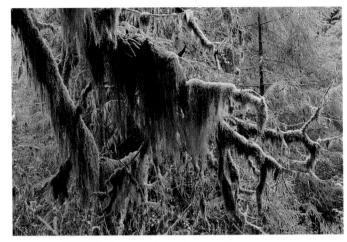

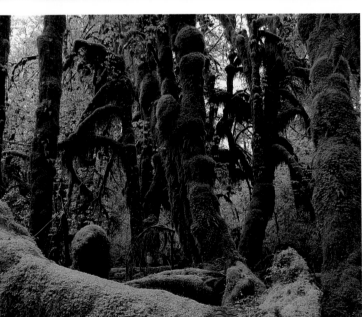

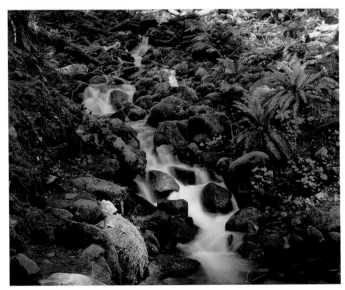

Green Leaves

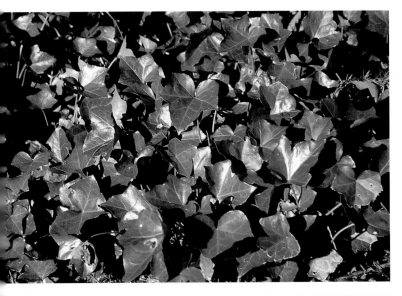

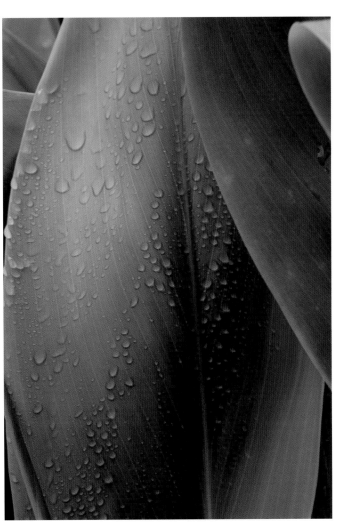

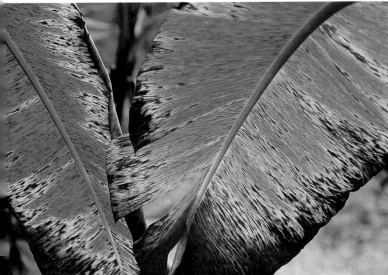

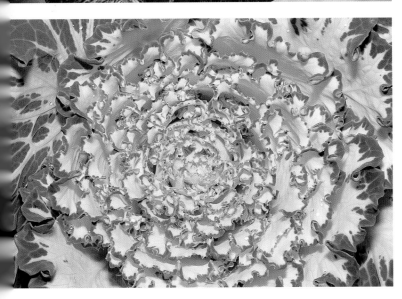

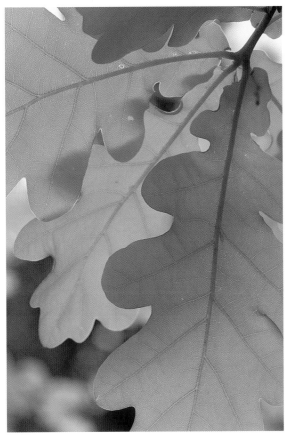

Autumn Leaves

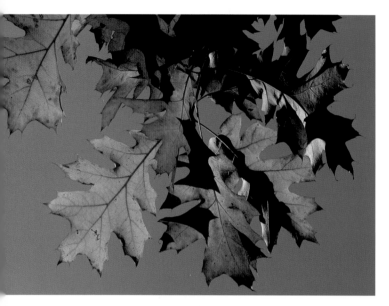

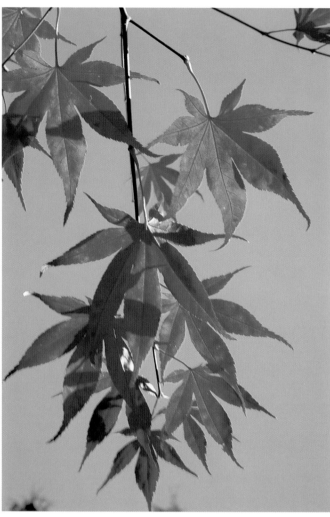

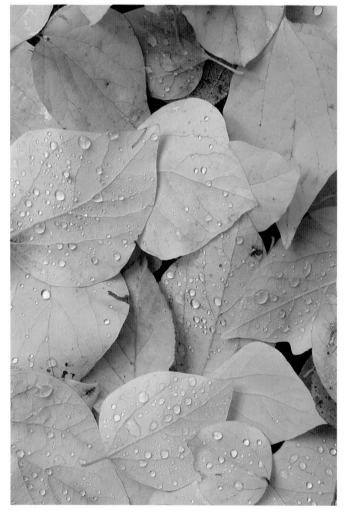

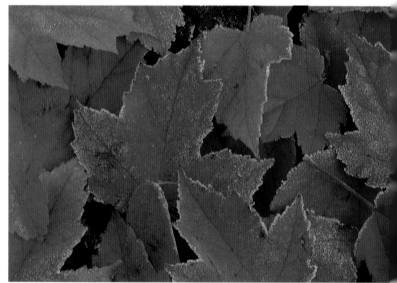

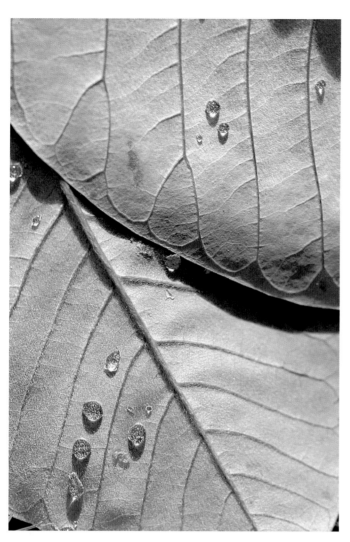

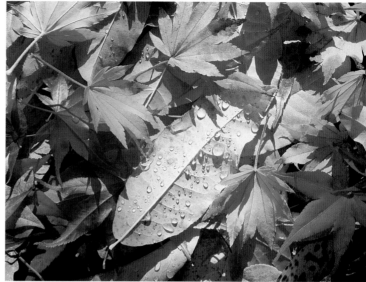

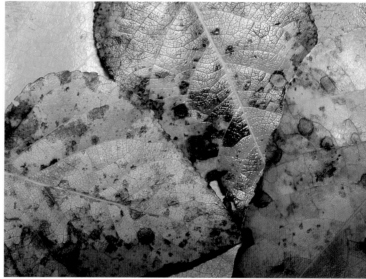

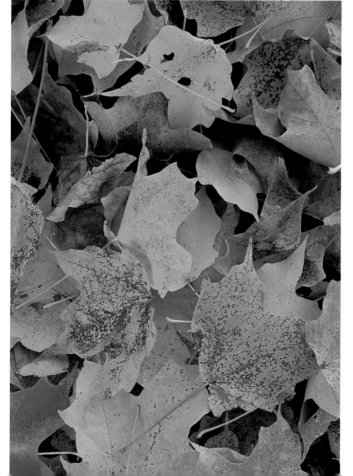

Autumn Leaves

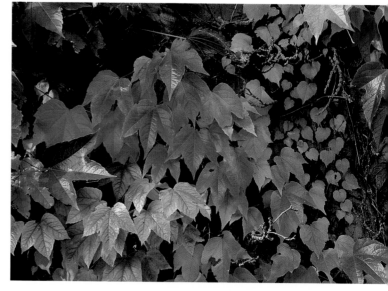

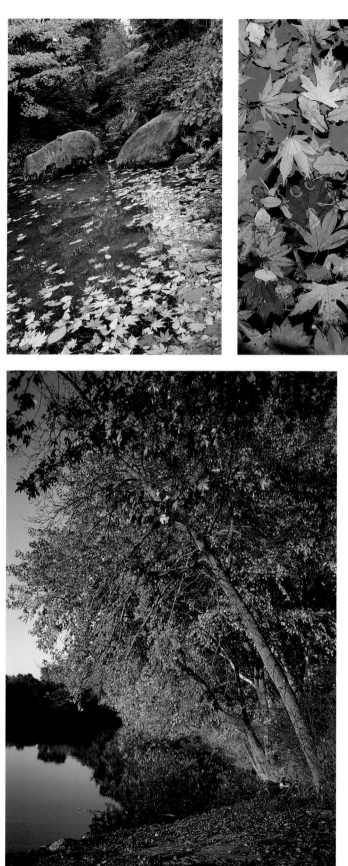

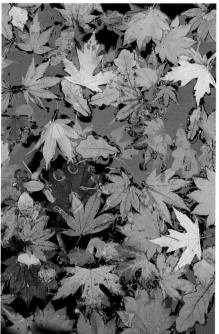

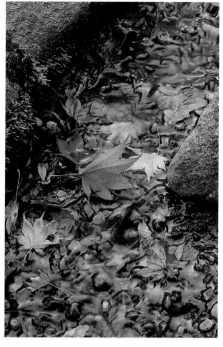

Cold-Weather Trees

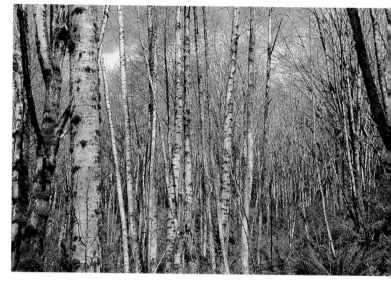

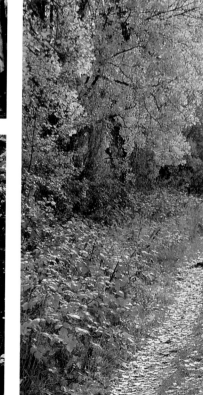

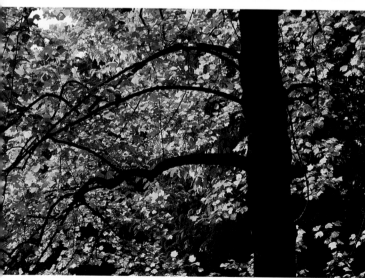

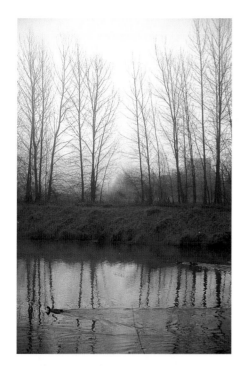

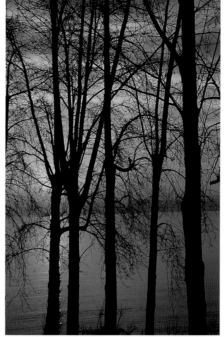

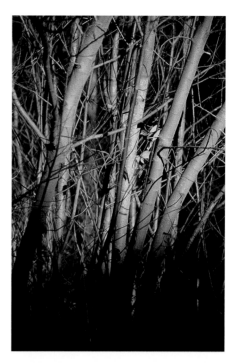

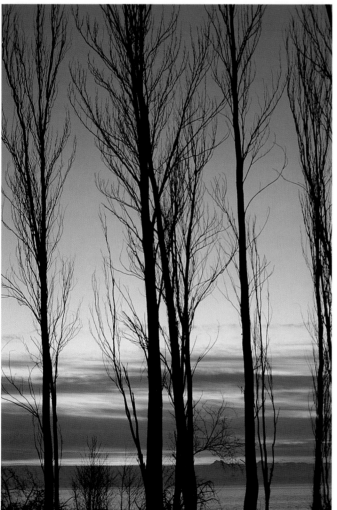

Winter Leaves

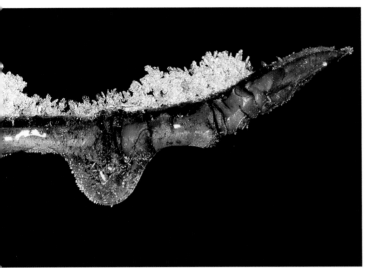

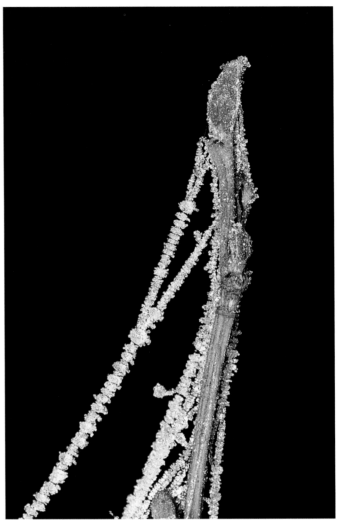

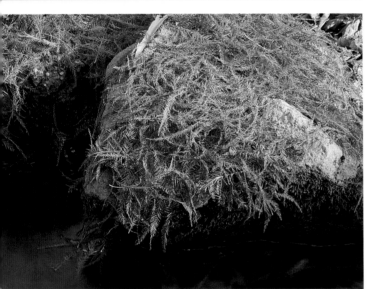

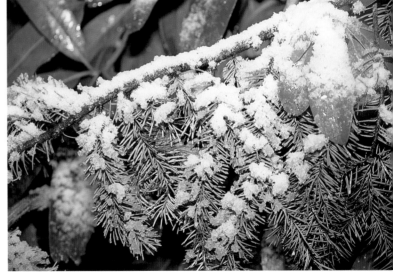

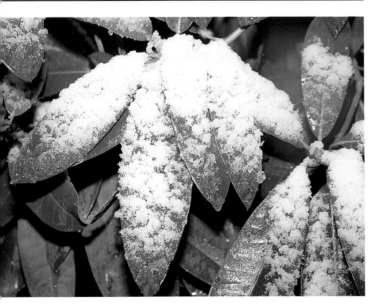

Evergreens

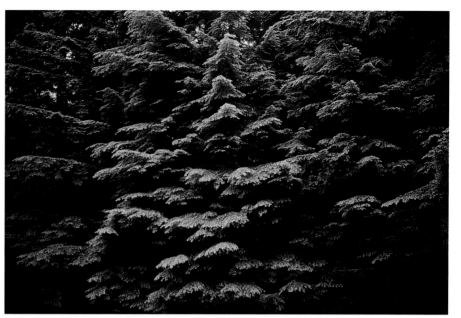

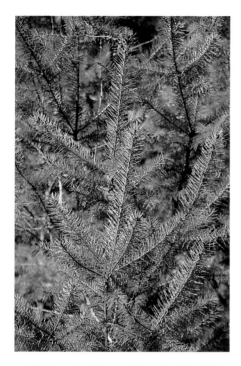

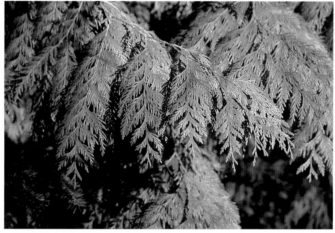

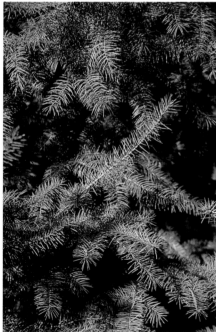

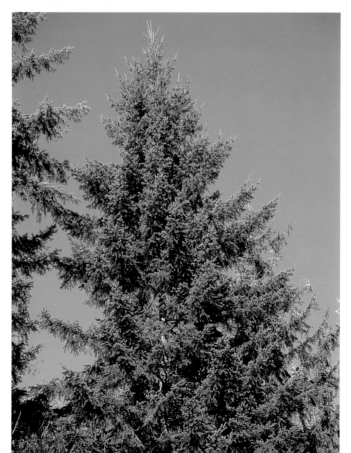

Fruits

Berries

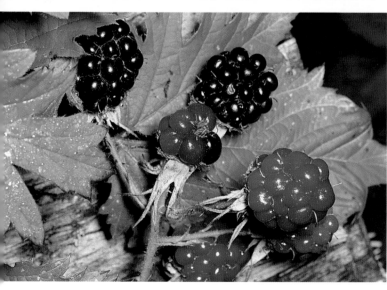

Miscellaneous

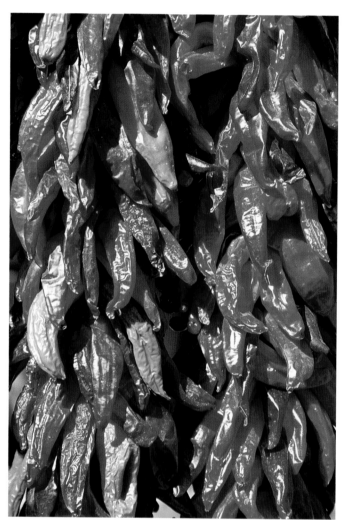

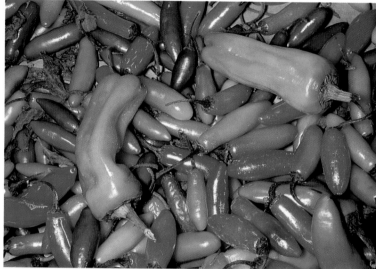

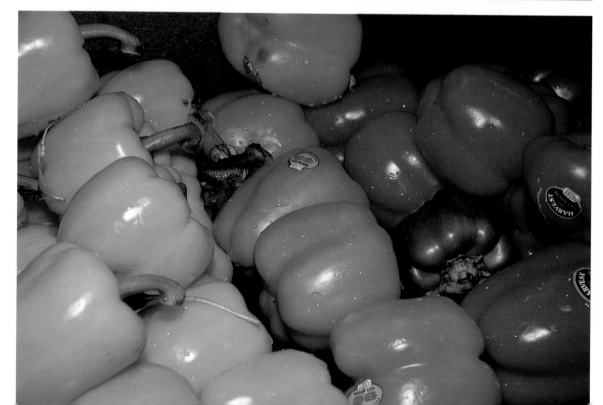

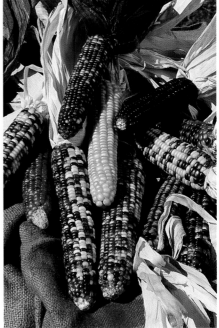

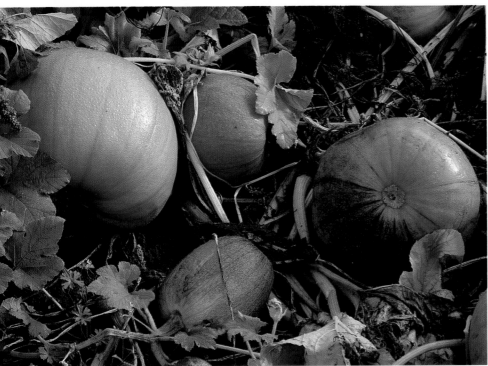

Rocky Terrain

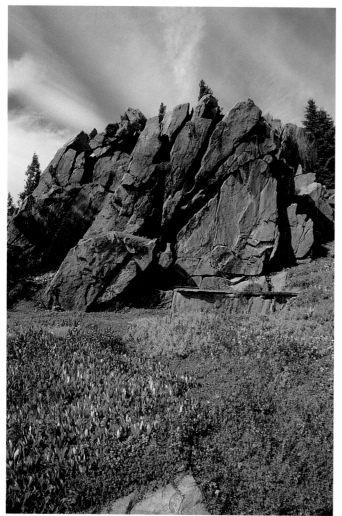

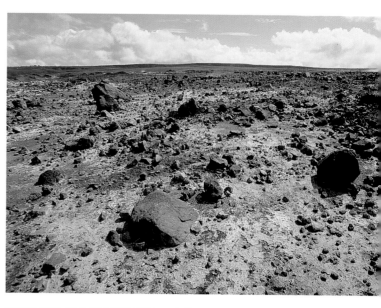

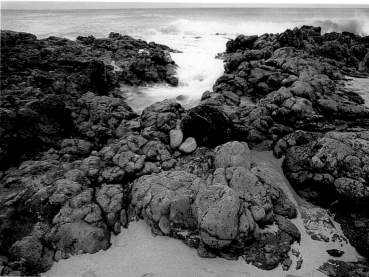

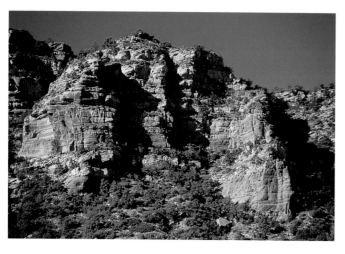

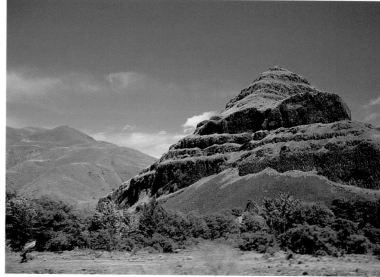

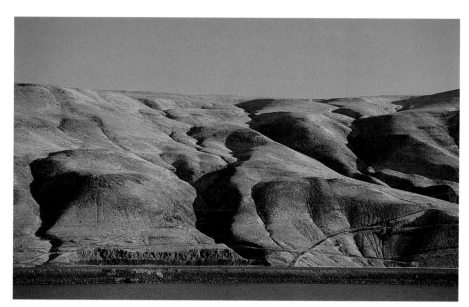

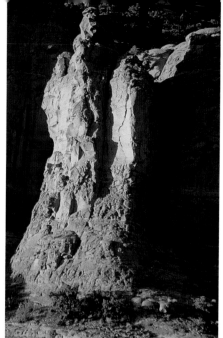

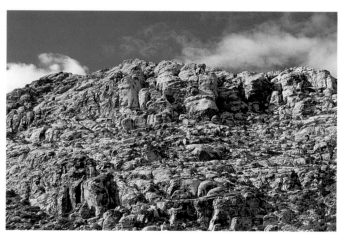

Sand

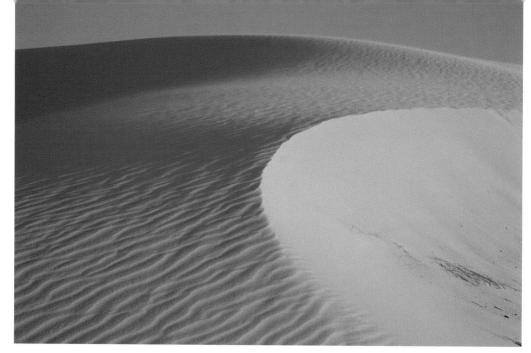

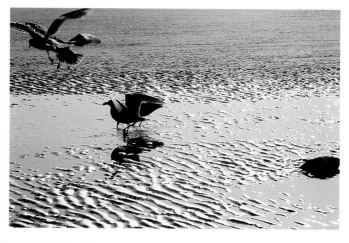

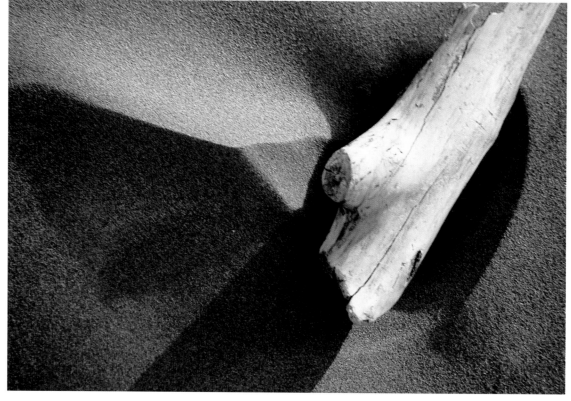

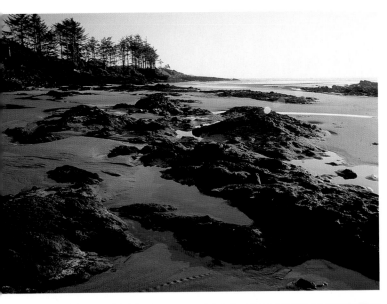

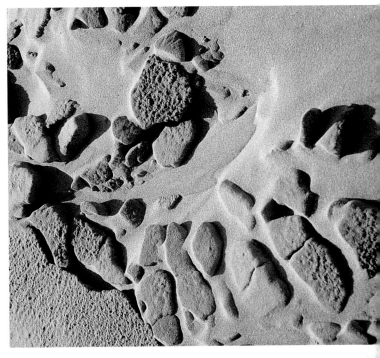

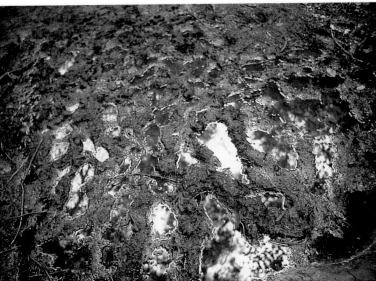

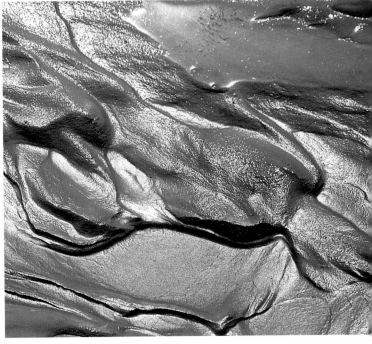

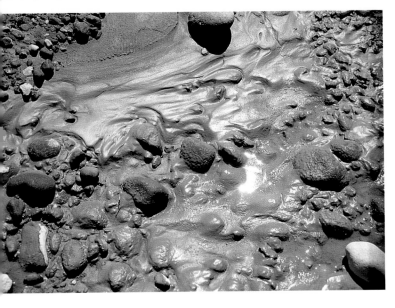

Stones

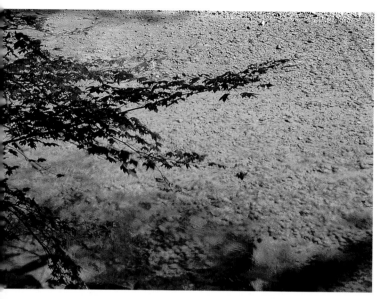

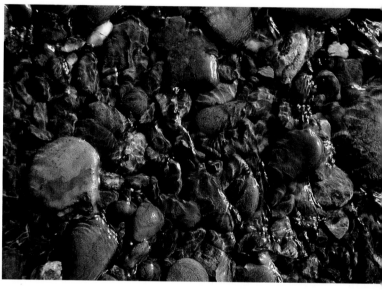

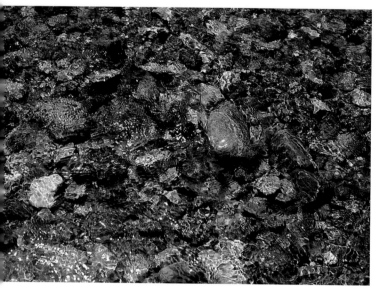

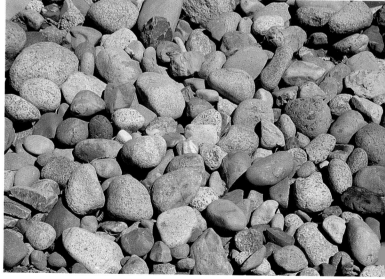

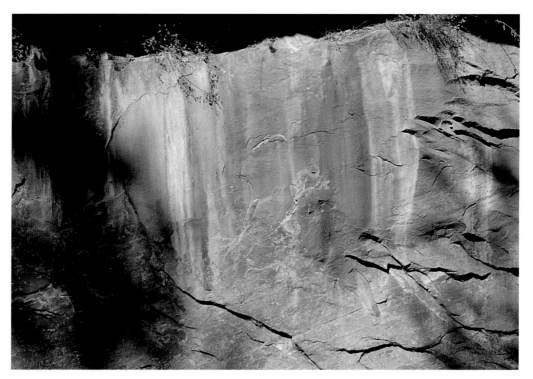

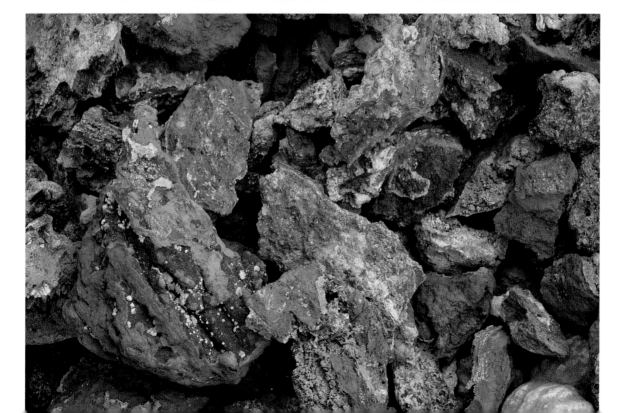

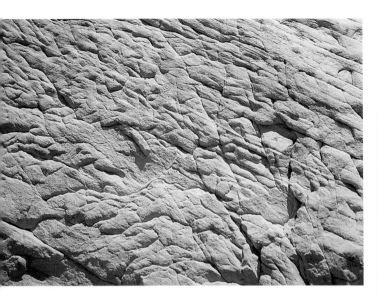

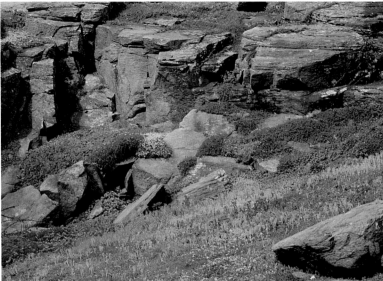

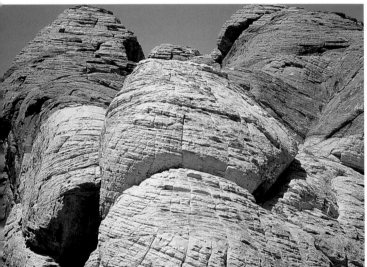

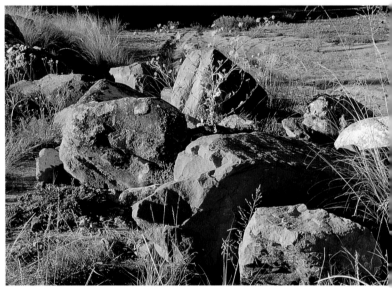

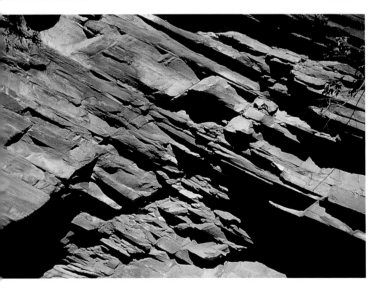

Nets and Ropes

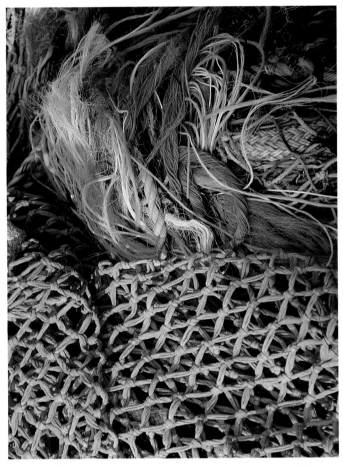

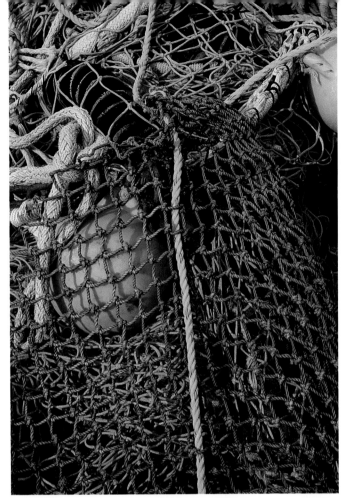

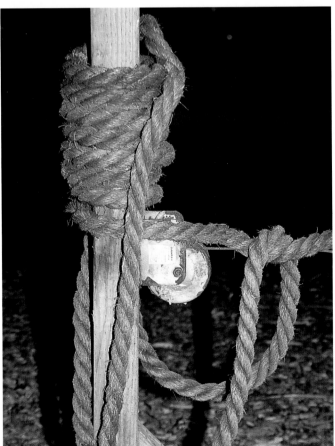

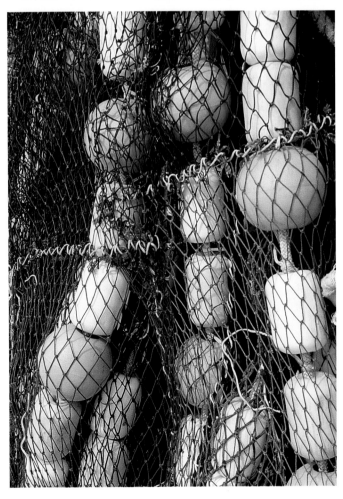

Rusted Metal

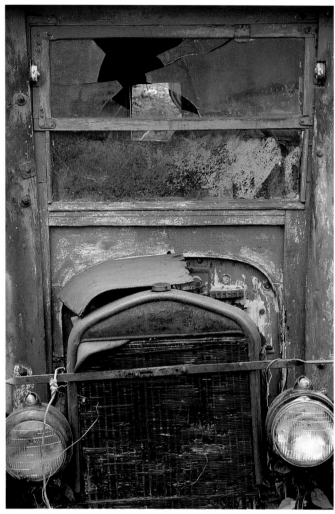

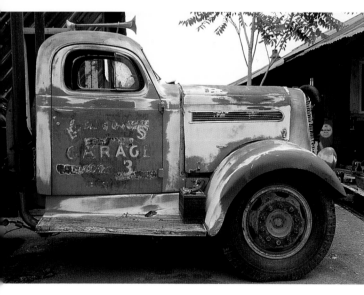

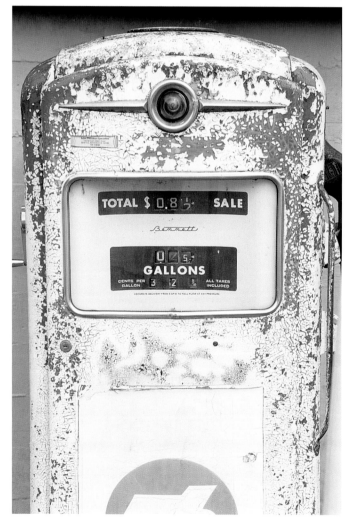

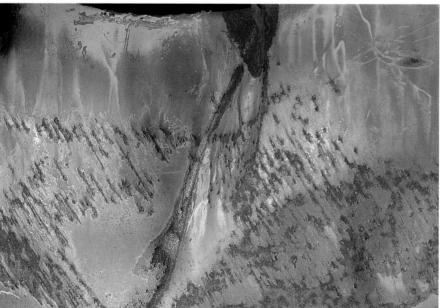

The White Doorknob

Materials

Surface
Crescent cold-pressed watercolor board

Brushes
⅝-inch (16mm) bright brush
⅞-inch (22mm) flat brush
No. 4 round brush

Color Palette

Golden Fluid Acrylics
Dioxazine Purple, Hansa Yellow Light, Payne's Gray, Titanium White, Transparent Yellow Iron Oxide

Golden Heavy Body Artist Acrylics
Cadmium Red Light, Cadmium Yellow Light, Cerulean Blue Chromium, Titanium White, Ultramarine Blue, Ultramarine Violet

Daniel Smith Ultimate Acrylics
Quinacridone Gold, Quinacridone Sienna

Other
Straightedge
2B graphite pencil
Kneaded rubber eraser
Spray fixative
Golden Acrylic Molding Paste
1-inch (25mm) putty knife
Small palette knife (optional)
Small craft or utility knife
SimAir original frisket film, matte finish
Golden Acrylic Gesso
Plastic or canvas tarp or lots
 of newspapers
Spray bottle with setting for fine mist
Container for water
Clean kitchen sponge
Small natural sponge
Thick, absorbent paper towels
Hair dryer

With the use of acrylic molding paste, Steve Whitney created a very lifelike bas-relief of the stone in the composite reference photo below. If you run your fingers over the painting, you would swear that it is the real thing.

I came upon the stonework while searching for reference photos in Tucson, Arizona, a few years ago. I realized when I made the photo that, regardless how the image was used, the dark shadows around the deeply recessed door would have to be lightened or eliminated and that the door, even though it had a weather-beaten look, could be replaced with something more appealing. Three years and many doors later, I came across the perfect door, part of an old garage in Mendocino, California.

To create the reference photo in Photoshop, I flopped the stonework horizontally because I felt it would make a better composition. Then I relocated the doorknob by cutting and pasting it in place and cloning areas around it to hide any seams. I also removed the glare on the doorjamb by adjusting the output levels and cloning darker areas over the highlight. With a few adjustments, the two altered images were put together for the final composition.

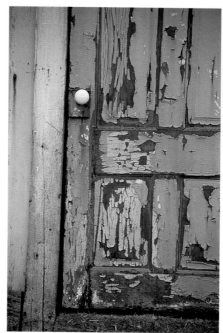

Reference Photos

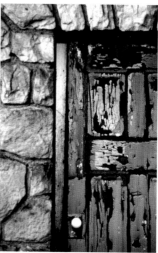

Composite Photo

1. Draw the Subject

Lay out the painting with a 2B graphite pencil. Use a straightedge to draw the long straight lines of the door frame. Sketch the stones and boards freehand. Use something round, like the bottom of a Golden Fluid Acrylic bottle, to trace the shape of the door knob. When you are done with the drawing, use the kneaded eraser to clean up smudges. Spray the finished drawing with fixative and allow it to dry before continuing.

2. Build up the Stone Wall and Mask the Door

Use your putty knife to apply a layer of acrylic molding paste between ⅟₁₆" and ⅛" (0.2mm and 0.3mm) thick to the shapes of the stones. Try to follow the edges of the stones but don't worry about being too precise. A small palette knife can be useful for getting the paste into tight corners. Use the putty knife to scrape back unwanted molding paste from the mortar channels between the stones. Finish building each stone by lightly troweling the shape with the flat of the putty knife blade. Take care not to over-work the surface. Set the painting aside and allow the molding paste to dry completely.

When the molding paste has hardened, mask the doorway portion of the painting with frisket film. A small craft knife works well for cutting the film. Overlapping sheets of film is fine.

After applying the frisket film, turn the painting over and apply two coats of gesso to the back of the watercolor board to minimize warping. Allow to dry completely.

3. Underpaint the Stone Wall

Spread a tarp or newspapers on the floor and lay the painting face up in the middle. The tarp should be large enough to protect the floor from accidental spattering. Make sure all the bottles of fluid acrylics listed in the Color Palette on page 92 are within easy reach, with their small, flip-up caps open and ready to go. Fill your spray bottle and water container with clean water and have them close at hand, along with a damp sponge and plenty of paper towels.

Use your spray bottle to liberally mist the unmasked stone wall. Squeeze various combinations of all the fluid acrylic colors onto all the stones, allowing different colors to mingle. You can roughly follow the color scheme shown in the photograph to the right, or make your own. It is not necessary to entirely cover the stones. Thin lines of paint will do the job.

Immediately spray the paint with water, so that it begins to spread freely. Use your kitchen sponge to help move paint around, to remove paint and to add texture. Use dry paper towels for the same purpose. The goal is to create thin, general patterns of textured color. You will add the finishing touches later. Spray as needed to keep the paint wet and workable. Add more paint if you like and continue spraying, sponging, wiping off and adding more paint until you are satisfied.

Use your hair dryer to completely dry the rock area. Put away your fluid acrylics. The rest of the painting will be done with Golden Artist Acrylics and Daniel Smith Ultimate Acrylics.

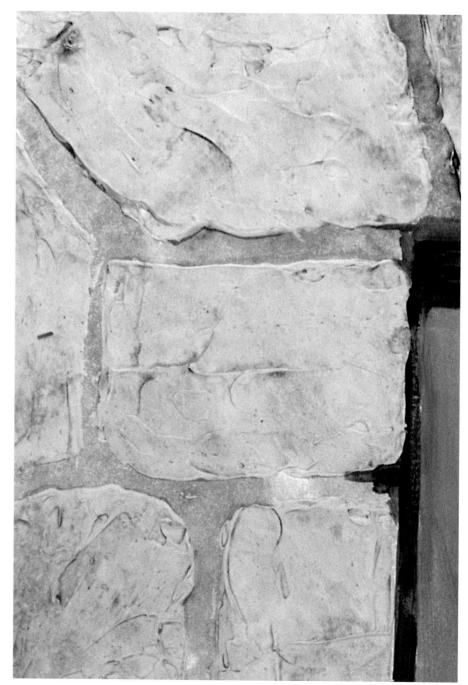

4. Underpaint the Door

For the door panels, create four color mixtures—dark reddish brown (Quinacridone Sienna and a little Ultramarine Blue), light reddish brown (the dark reddish brown mix and Titanium White), muted blue-green (Cerulean Blue Chromium, Cadmium Yellow Light, Titanium White and a touch of Cadmium Red Light), and creamy yellow (Cadmium Yellow Light, Titanium White and a touch of Ultramarine Violet).

Paint the rectangular door panels boldly and loosely with the mixtures from above. Use your ⅞-inch (22mm) flat brush for the large areas and your no. 4 round brush for the dark, narrow crevices bordering the panels. Indicate the basic color patterns in the door but don't worry about specific details at this point.

Paint the door frame with your ⅝-inch (16mm) flat brush. Paint the horizontal part of the door frame with the dark reddish brown mixture. Paint the vertical part of the door frame with a mixture of Ultramarine Violet, Titanium White and a touch of Quinacridone Gold.

Paint the brass plate around the doorknob with a mixture of Quinacridone Gold and a touch of Ultramarine Violet. For the lighter portion of the brass plate, lighten this mixture with a little Titanium White.

At this stage, the only white paper showing should be the door knob.

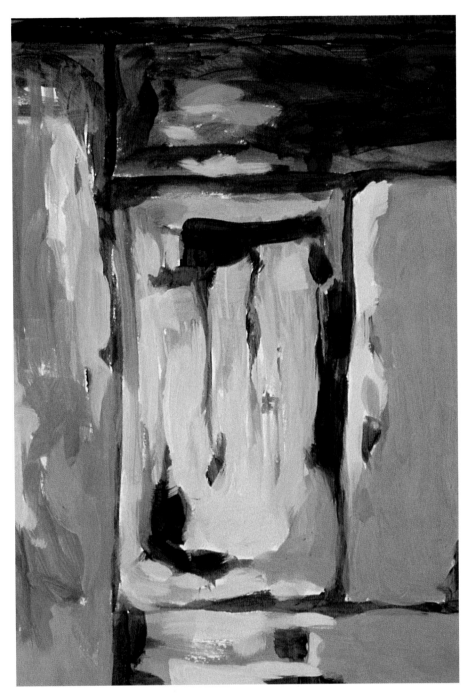

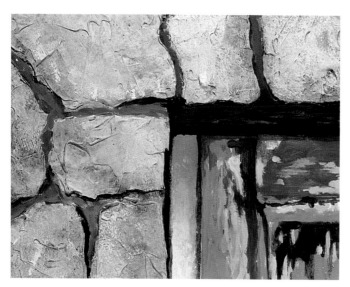

5. Refine the Stones and Crevices

For the stone detailing, you'll need to mix up a pale violet (Titanium White with a little Ultramarine Violet and even less Cadmium Yellow Light), pale gold (Titanium White with a little Cadmium Yellow Light and even less Ultramarine Violet), dark reddish-brown (Quinacridone Sienna and a little Ultramarine Blue) and dark gray-green (Ultramarine Blue, Quinacridone Gold, a little Ultramarine Violet and a touch of Titanium White). Apply the colors sparingly with a small natural sponge to make the stones darker in some places and lighter in others. Don't make your dark areas too dark, and take care to let the underpainting peek through. The goal is a thin, mottled effect characteristic of granite.

For the mortar channels between the stones, mix Quinacridone Gold, Quinacridone Sienna and a touch of Ultramarine Blue to create a dark ochre. Using your no. 4 round brush, apply this paint to the narrow lines of mortar between the stones. Use dark reddish brown to indicate shadows along the edges of the stones.

Add a little Quinacridone Sienna to Ultramarine Blue to create a cool, near-black for the crevices. If the mixture

appears too blue, add a little Cadmium Red Light to warm it. Apply this mixture with the no. 4 round to the darkest areas in the crevices between the stones, in the door frame and in the door proper. Drag thin lines of this color over the horizontal part of the door frame to create the effect of wood grain.

Create the reflective shine on the upright part of the door frame by applying pale gold (see mixture above) with the wadded corner of a dry paper towel. Daub color thickly to the place where the reflection is strongest, then push the paint upward and downward along the door frame to create smooth transitions. After the reflection dries, use a paper towel to rub a thin layer of Ultramarine Violet over the outer edges of the reflection, as needed, to make the transition gradual. Also working with a towel, rub a thin coat of Quinacridone Gold over the remainder of the upright to reduce the intensity of the violet.

Mix a thick, creamy white by adding a touch of Cadmium Yellow Light to Titanium White. Use your no. 4 round brush to paint the entire doorknob. When the white is dry, paint a thin crescent of Cerulean Blue along the bottom of the doorknob and a hint of color to the brass plate.

6. Add the Final Touches

Use a natural sponge to adjust the colors in the stones, applying one or more of the color mixtures used in the previous step for this area.

Use your no. 4 round brush to restate or modify the mortar channels between the stones, reinforce the shadow lines along the edges of the stones, introduce additional shadow lines along ridges and crevices within the stones, and darken the crevices along the door frame.

Add a tiny touch of Cadmium Yellow Light to a small pile of Cerulean Blue with your no. 4 round brush. Add enough Titanium White to create a pale blue-green. Keep the mixture thick. Use your no. 4 round brush to add a few small touches of this color to various spots on the door panels. Also add thick notes of muted blue-green and creamy yellow (see mixtures in Step 4) to already existing areas of those colors to indicate less weathered areas of paint.

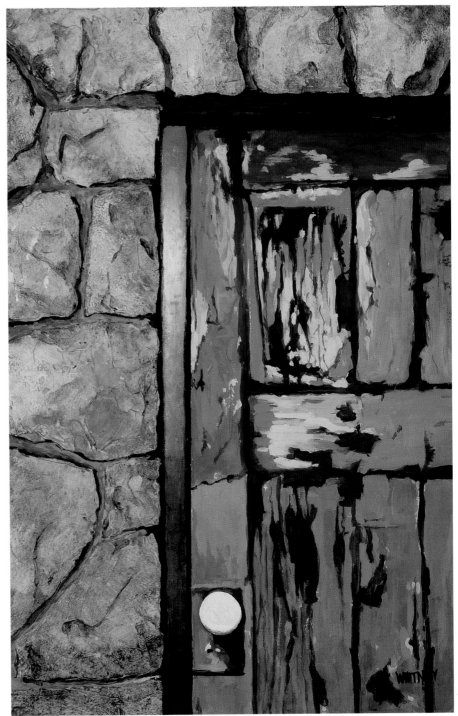

The White Doorknob
Steve Whitney
27 ½" × 18" (70cm × 46cm)
Acrylic and molding paste on Crescent cold-pressed watercolor board

Weathered Lumber

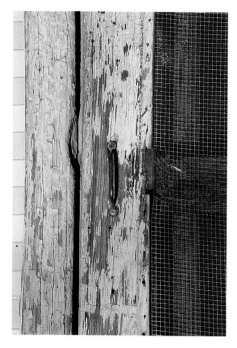

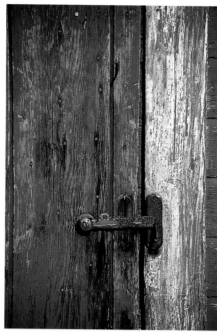

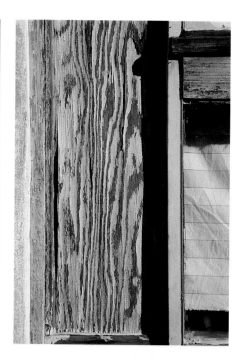

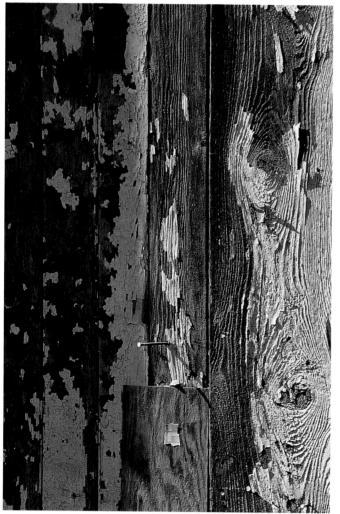

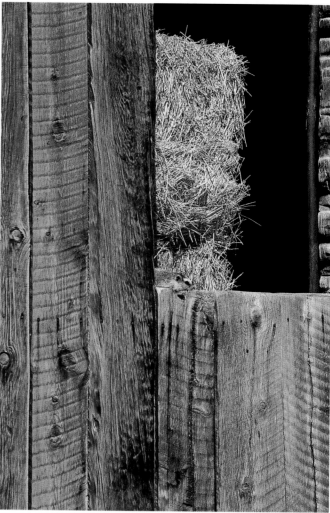

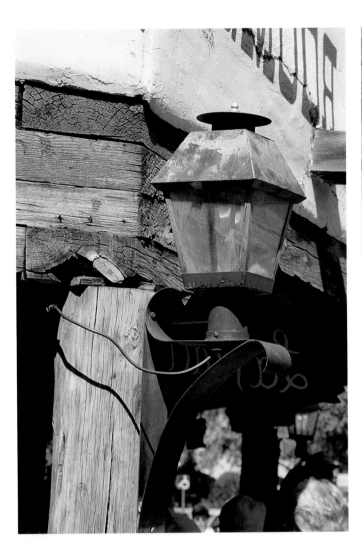

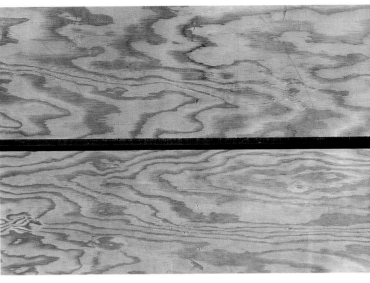

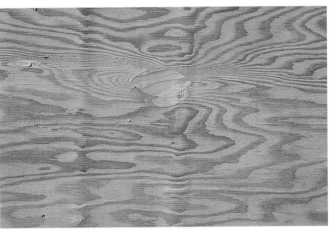

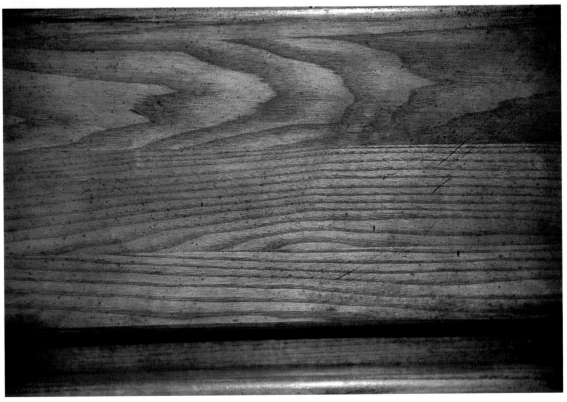

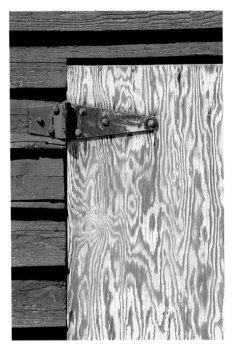

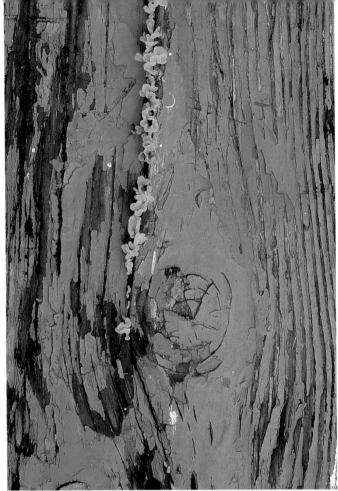

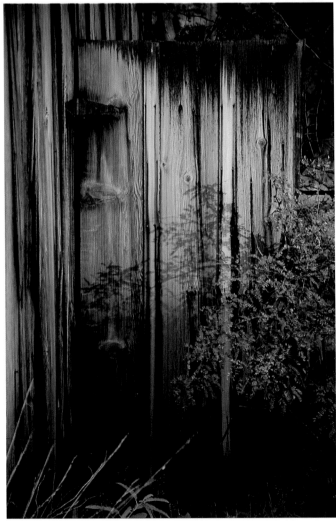

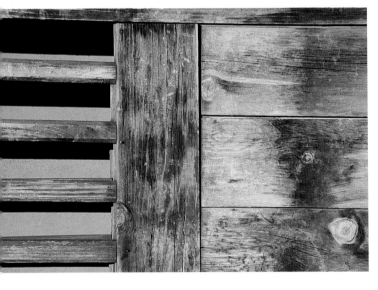

Bricks

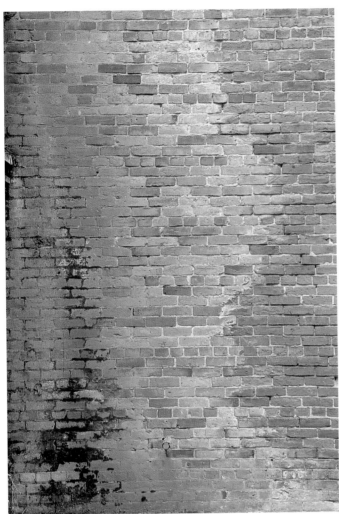

by Gary Greene

Arcs, Radii and Rectangles

Materials

Surface
300-lb. (640gsm) cold-pressed watercolor paper

Brushes
Nos. 8 and 10 round watercolor brushes

Color Palette

**Faber-Castell Albrecht Dürer
(Water-soluble colored pencil)**
Burnt Ochre, Dark Cadmium Yellow, Ivory, Light Flesh, Terracotta, Van Dyck Brown, Warm Grey II, Warm Grey III

**Faber-Castell Polychromos
(Oil-based dry colored pencil)**
Burnt Ochre, Burnt Sienna, Dark Sepia, Terracotta, Van Dyck Brown, Warm Grey I, II, III, V, VI

Sanford Prismacolor Colored Pencils
Dark Umber, Light Umber, Pumpkin Orange, Sienna Brown, Terracotta, Tuscan Red, Warm Grey 90%

Other
2B graphite pencil

Kneaded eraser

Electric pencil sharpener

Metal straightedge

Plastic circle template

Compass with beam extension and 2B graphite lead

Container for water

Cotton swabs

Cotton balls

Paper towels

Gift shops—so-called tourist traps in particular—are excellent sources for reference photos. During a recent business trip, I could not help but notice such an establishment on the main highway through the town I was staying in. After passing it by several times, I decided to stop in and see what I could find.

It turned out to be a virtual treasure trove! I found, among other interesting items, clay pots, serapes, weather-beaten wood artifacts and several old wagon wheels in varying states of entropy. One of my favorites is the image you see here. Unfortunately, there was a tree nearby casting dappled shadows on the scene, something I did not wish to include in my painting.

I wanted to see what the image would look like without the shadows, so I scanned the photo and opened it in Photoshop, where I used the rubber stamp and cloning tools to remove the shadows cast by the tree. I also changed the composition by flipping the wagon wheel's hub from the right to the left bottom corner.

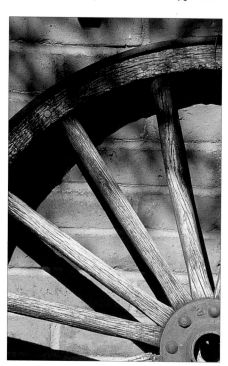

Reference photo

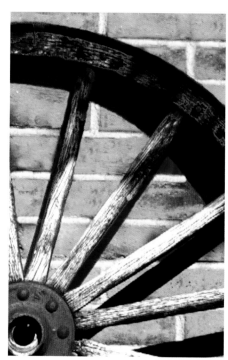

Composite Photo

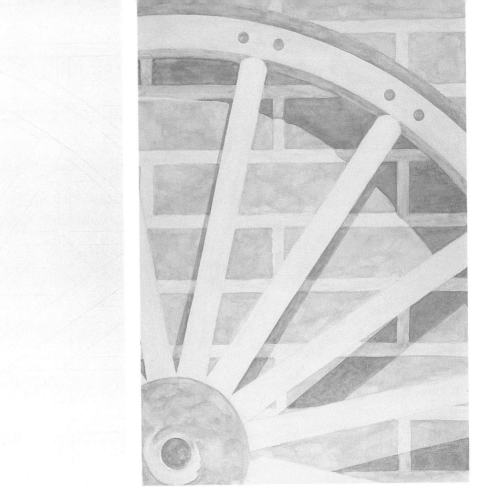

1. Prepare the Layout

First, roughly lay the painting out with a 2B graphite pencil, then make a tighter layout over this with a pencil, straightedge, compass with beam extension and circle templates to correct photographic distortion. Lay the painting out a third time with Albrecht Dürer Dark Chrome Yellow and Albrecht Dürer Warm Grey lines drawn next to the graphite lines. Remove the graphite lines with a kneaded eraser, leaving light colored pencil lines.

2. Underpaint with Water-Soluble Colored Pencils

Underpainting colors the paper with minimal impact on the paper's tooth, which in turn allows various textures to be created. Water-soluble colored pencils, like the Albrecht Dürer pencils used in this step, will produce a mottled look in the underpainting which will help enhance textures. To maintain a consistent coverage of pigment, keep pencils well-sharpened.

Begin with the wood spokes and wheel, lightly layering Light Flesh and Ivory lengthwise along the spokes and wheel. Carefully wipe with a cotton ball to remove some of the pigment, which will produce a lighter underpainting. Next, dissolve the pigment with water, using a no. 10 round brush and the same lengthwise stroke used to lay the color down. Once this area is dry, move on to the mortar.

For the sunlit mortar, use Warm Grey II, layering the area unevenly with circular strokes. Apply water with a no. 8 round watercolor brush; this will create lighter and darker areas in the mortar. After the sunlit mortar is dry, lay in the shadowed areas of mortar with Warm Grey III. Use a no. 8 round brush and clean water to blend the shadowed mortar areas. Allow this to dry.

For the bricks, use a circular stroke to apply Dark Cadmium Yellow to the entire brick, both sunlit and shadowed,

and then wet this with a no. 10 round brush. Wait for the bricks to dry and then layer Burnt Ochre over the Dark Cadmium Yellow in the shadowed areas. Use the no. 10 round brush to wet this area and then allow it to dry before moving on to paint the rusted areas of the wheel.

Apply Terracotta with a circular stroke to the thin layer of rusted metal on the outer rim of the wheel and to the two bolts by either side of each spoke. Wet this area with a no. 10 round brush. For the rusted hub in the center of the wheel, use Van Dyck Brown and Burnt Ochre and then wet the area with a no. 8 round brush. Once the hub is dry, paint certain areas of the inner rim with Warm Grey II, as shown. After wetting the area and allowing it to dry, layer the remaining portions of the inner rim with Terracotta.

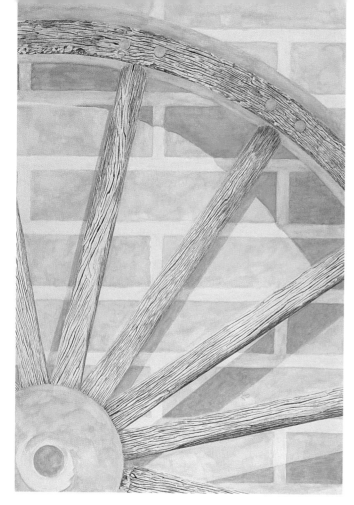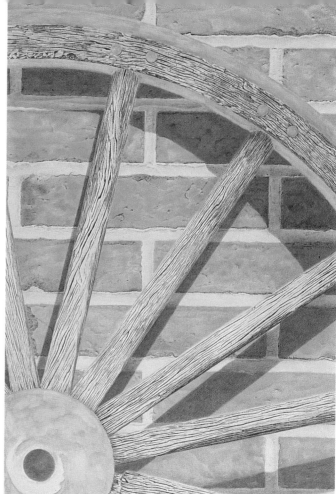

3. Create the Wood Texture

Now that the underpainting is complete, use Polychromos and Prismacolor "dry" colored pencils for the remainder of the project. Use oil-based colored pencils and keep a needle-sharp point on them at all times to help create a realistic wood texture. Constant sharpening with a quality electric pencil sharpener is a must. Soft, wax-based colored pencils simply cannot hold a sharp point without either breaking or quickly wearing down.

Lay out the largest, deepest cracks and dark areas with Dark Sepia and vary the thickness, shape and size of each. After layering the cracks with Dark Sepia and Van Dyck Brown, apply another coat of Dark Sepia until the paper surface is completely covered.

Draw surface cracks and lighter areas with Burnt Sienna and Van Dyck Brown to depict deeper weathering. To give the cracks dimensionality, leave a thin gap free of color to the left of each large crack on the spokes and on the bottom of the cracks on the wheel. Draw various horizontal strokes with Burnt Sienna, Van Dyck Brown and Dark Sepia for the larger dark, weathered areas.

4. Lay in Bricks and Mortar

For sunlit brick areas, color the deeper crevasses with Dark Sepia and Sienna Brown. Randomly apply Burnt Ochre and Terracotta, leaving some areas of the underpainting free of additional color. Blend and soften the pigment over the entire brick with a cotton swab. Lighten random areas with a kneaded eraser.

Where the wheel's shadows are cast onto the bricks, apply Dark Sepia over darker underpainted areas. Smooth the color with a cotton swab and then randomly reapply Dark Sepia.

Use the same process for the sunlit areas of mortar; apply Polychromos Warm Grey III, II and I, leaving the underpainting free of additional color in some areas, and then soften the pigment with a cotton swab. With Warm Grey VI, draw cracks between the bricks and mortar and the shadows cast by the bricks.

For the shadowed mortar areas, layer Warm Grey V over the darker underpainted areas in the wheel's shadow. Smooth the color with a cotton swab and then reapply more Warm Grey V randomly. Repeat until the desired effect is achieved.

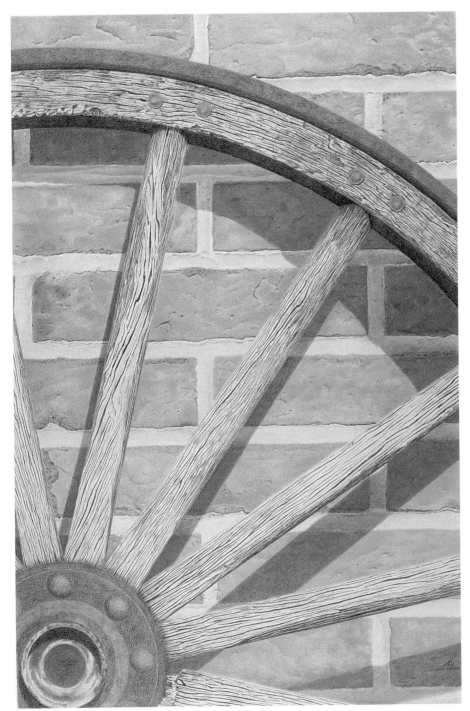

5. Create the Rust

Layer the darkest values on the hub, rivets and inside the wheel with Warm Grey 90% and Dark Umber. For the secondary shadow on the side of the wheel, use Dark Umber. Lightly color layers of Terracotta (Prismacolor), Tuscan Red, Pumpkin Orange, Light Umber, and Terracotta (Polychromos) over the rusted areas, including the shadows. Use Warm Grey II and III to color in the white areas in the inner rim of the hub. Repeat this process until most of the paper surface is covered but allow some of the underpainting to show through, which will give the appearance of rust.

Arcs, Radii and Rectangles
Gary Greene
23 ½" × 15 ¾" (60cm × 40cm)
Colored pencil on 300-lb. (640gsm) cold-pressed watercolor paper

Walls

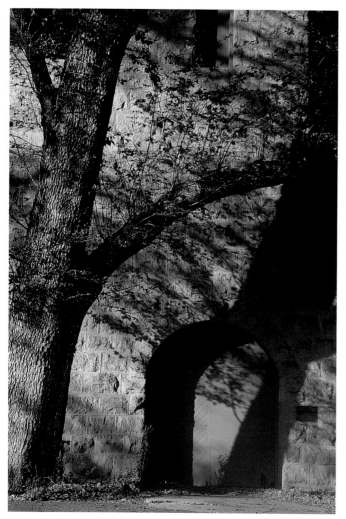

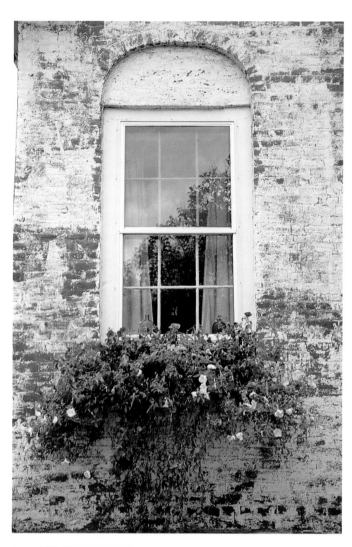

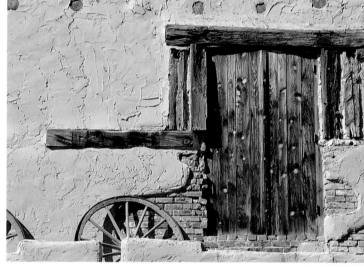

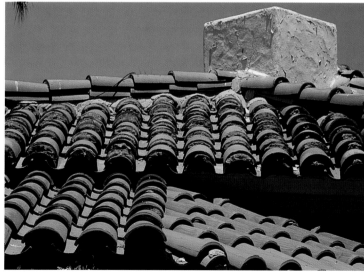

Pots

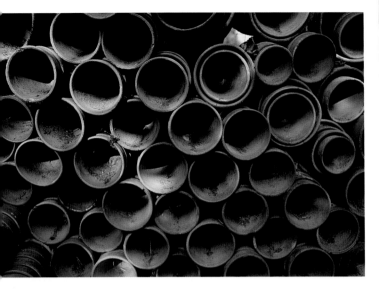

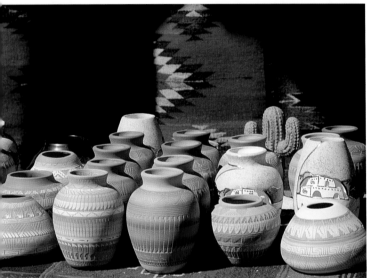

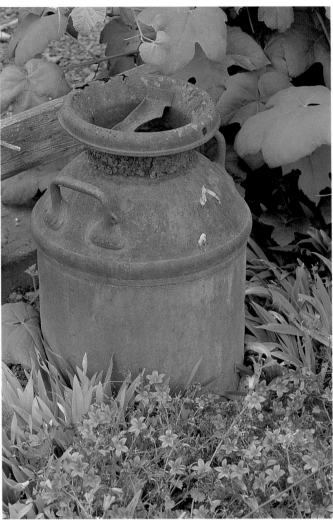

Baskets

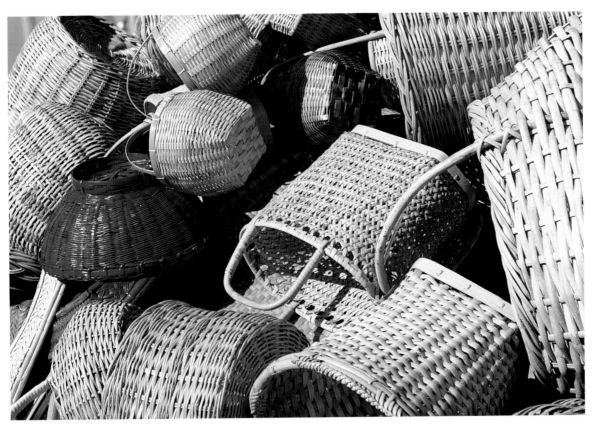

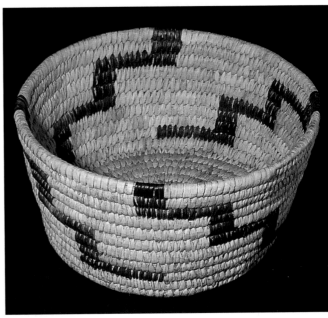

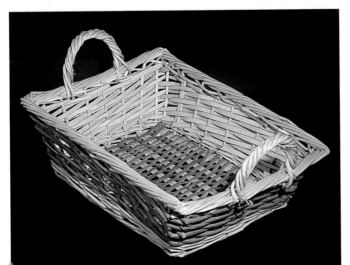

Fabrics

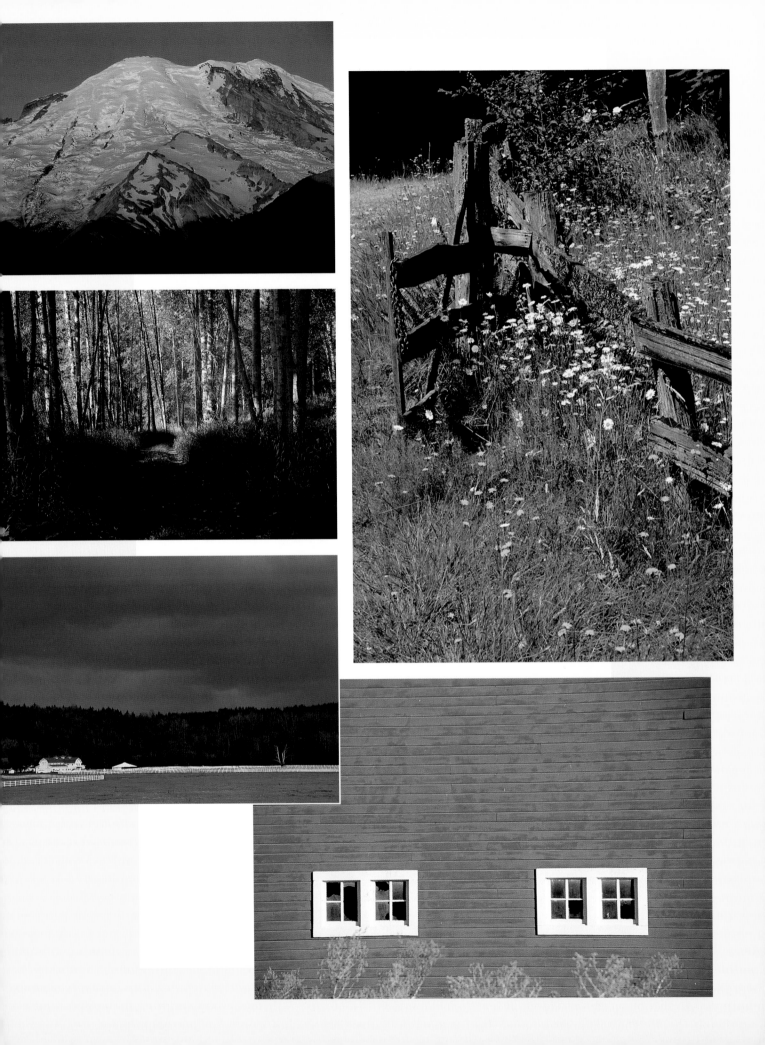

Backgrounds

The backgrounds included in this section are primarily elements that can be used in paintings. In other words, the photos are not necessarily complete compositions in themselves. There are reference photos that feature mountains, water or clouds that can be used for landscapes and silhouetted scenes that can be paired with either these elements, or some of the "abstract" backgrounds. Some reference photos in the Textures and Reflections sections can also be used as backgrounds.

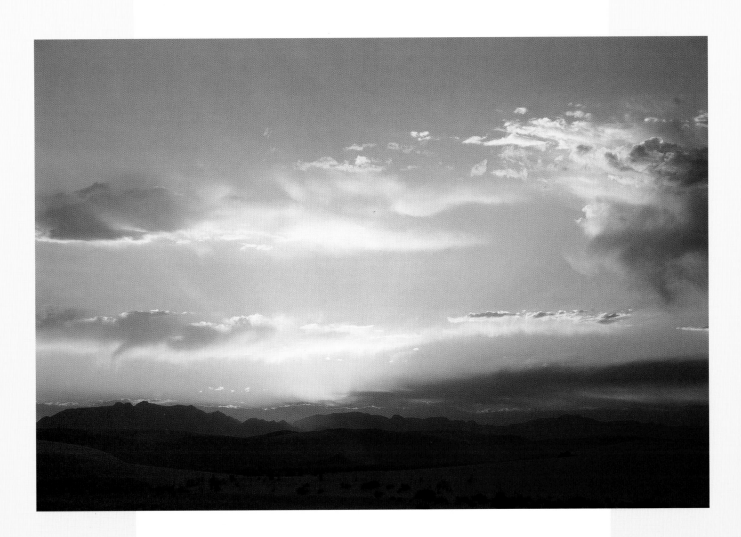

Sunrise and Sunset

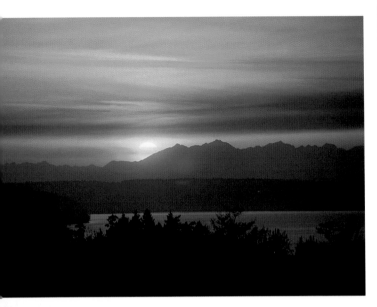

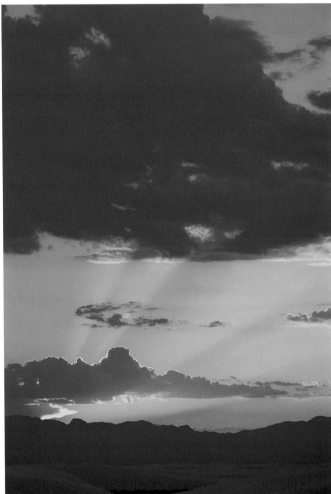

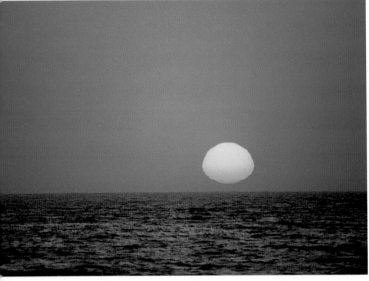

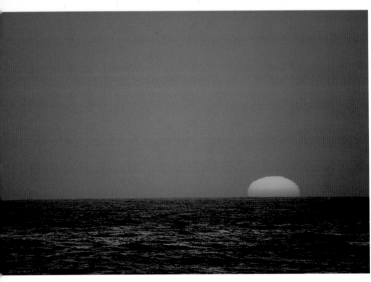

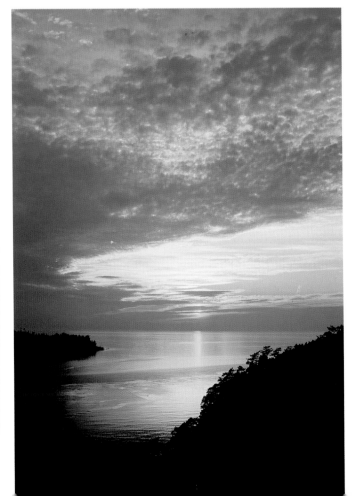

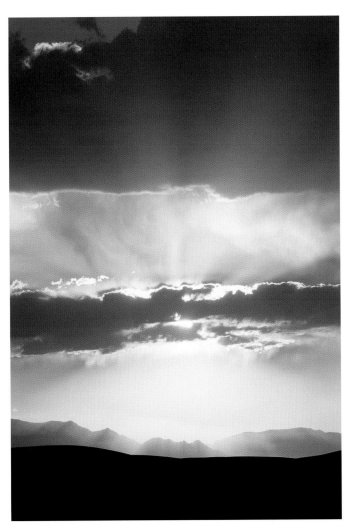

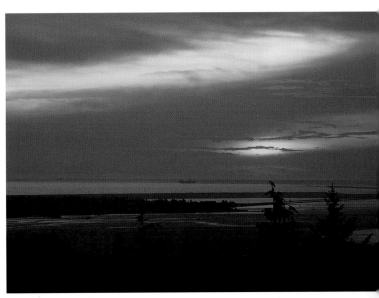

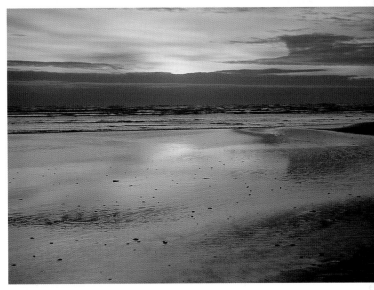

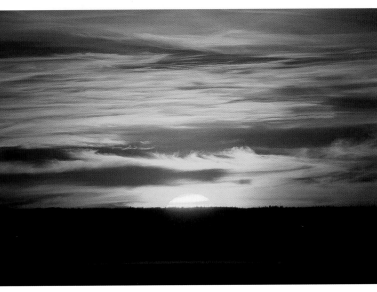

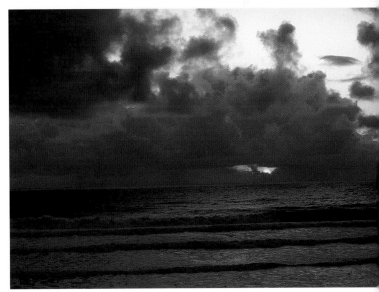

Dusk

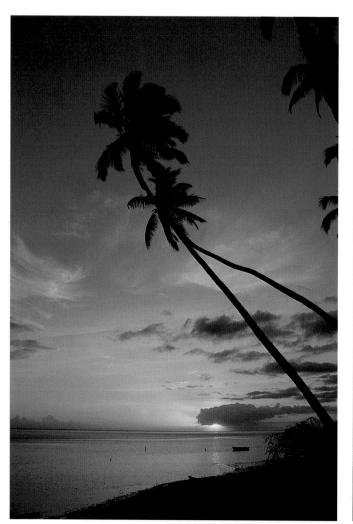

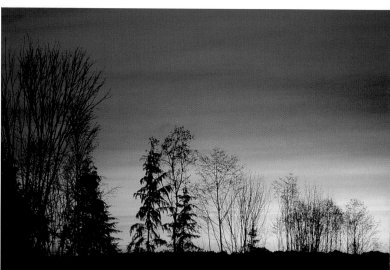

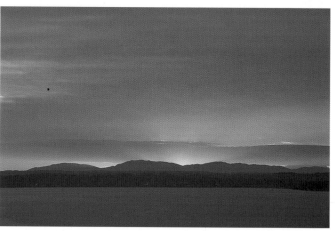

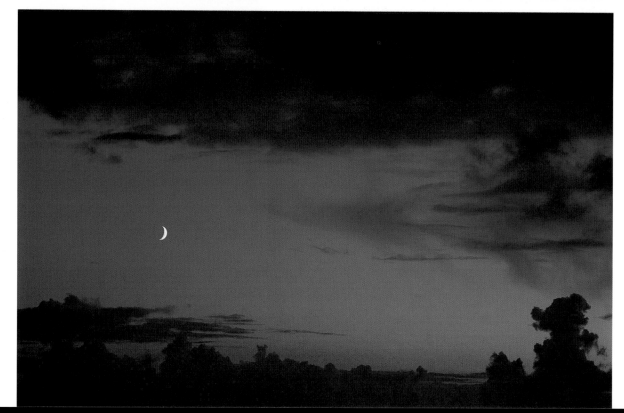

Sun-drenched Clouds

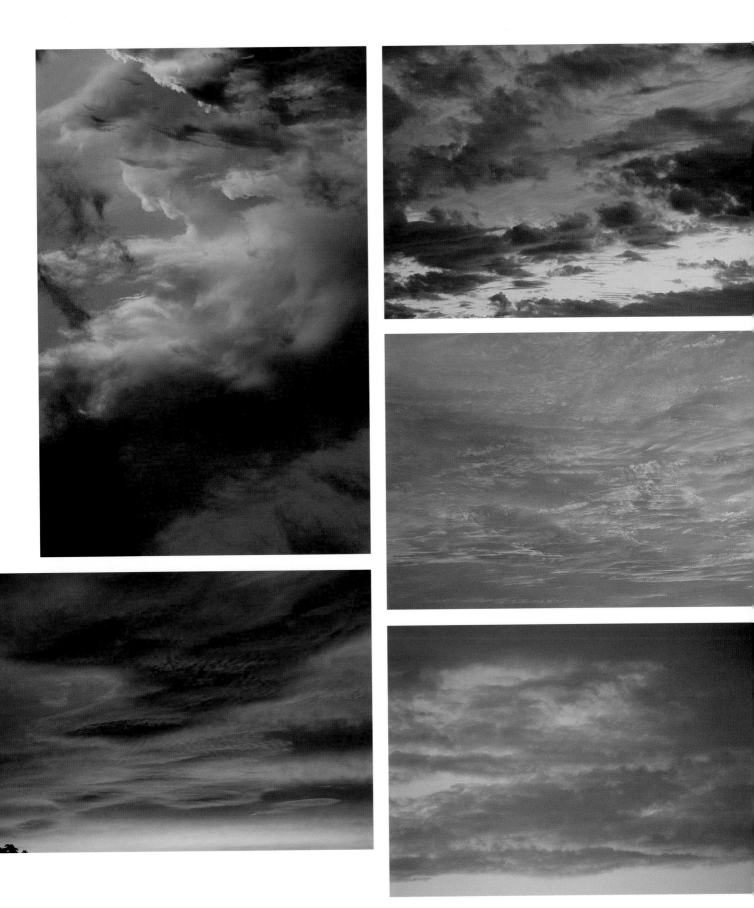

Clouds

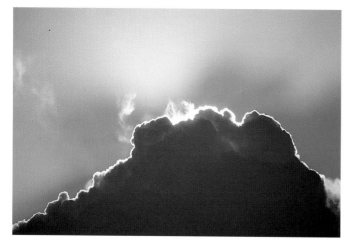

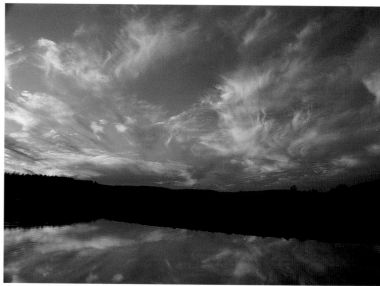

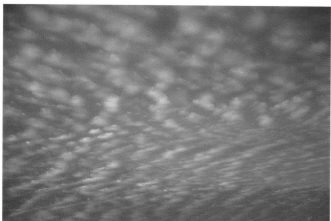

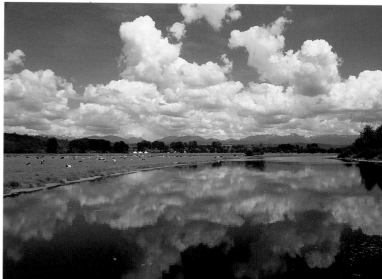

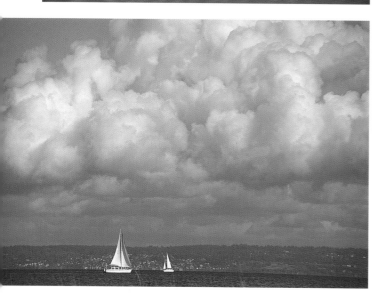

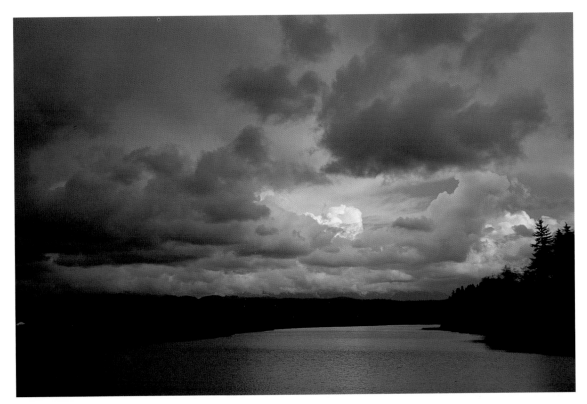

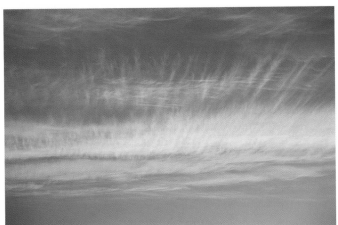

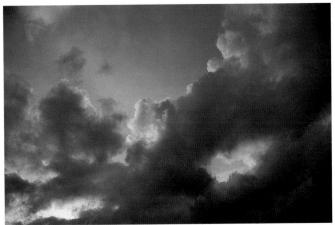

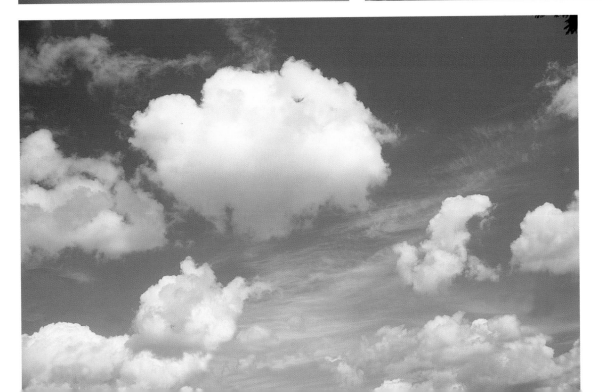

Rainbows

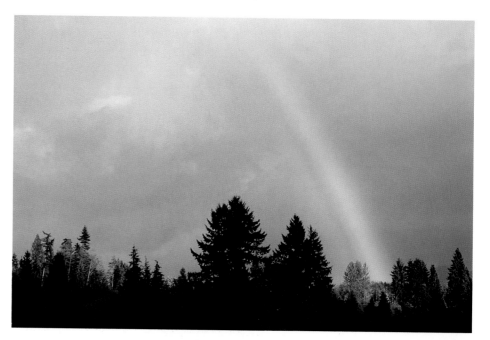

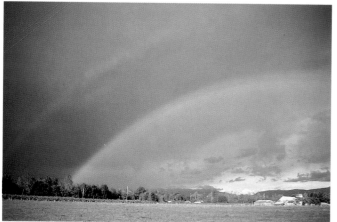

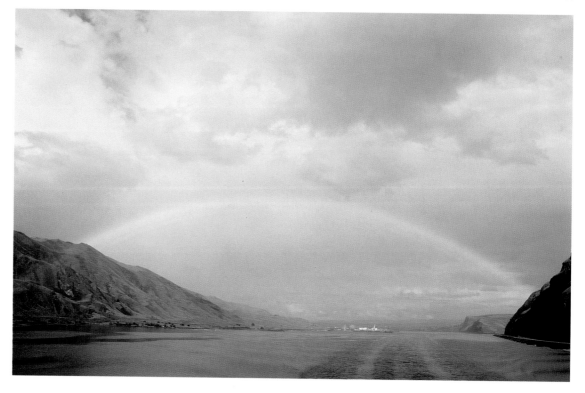

Rays of Light / Misty Light

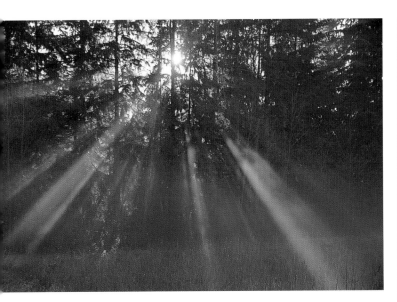

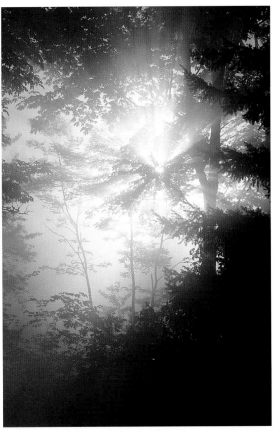

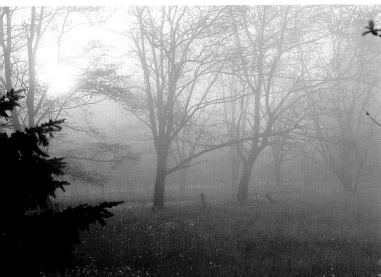

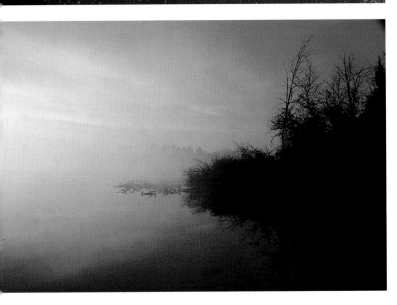

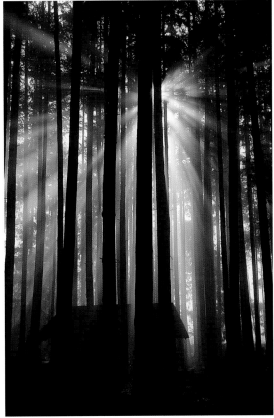

Fog / Mist

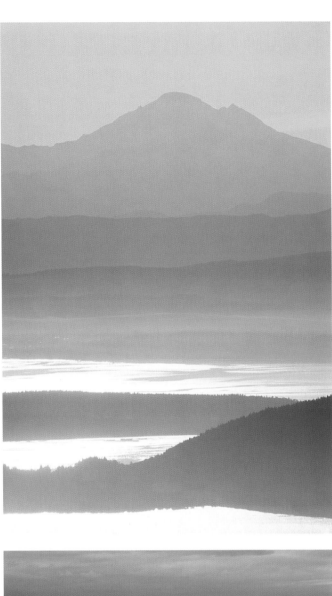

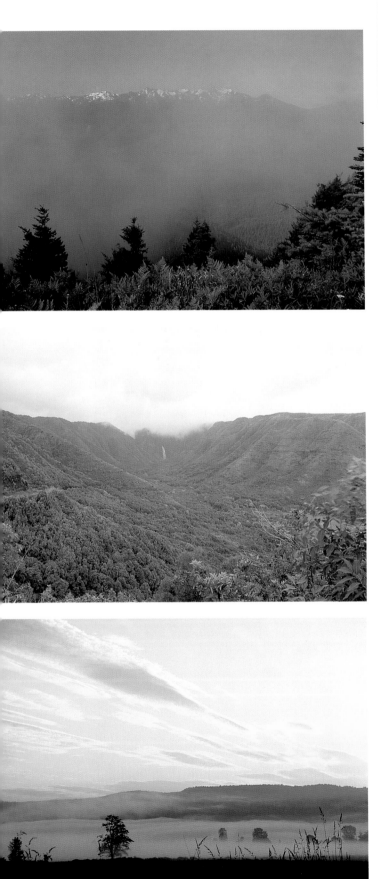

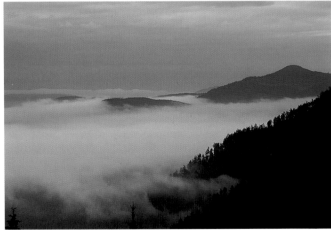

Winter Scenes

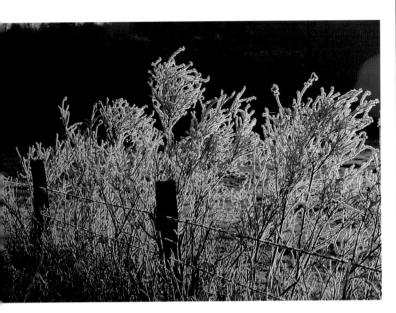

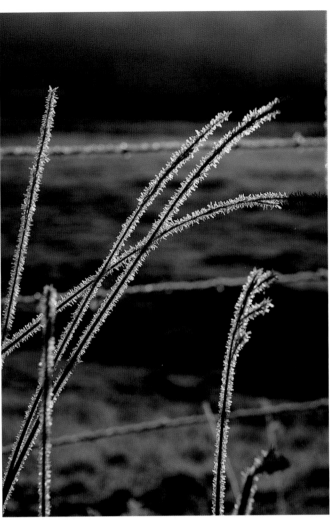

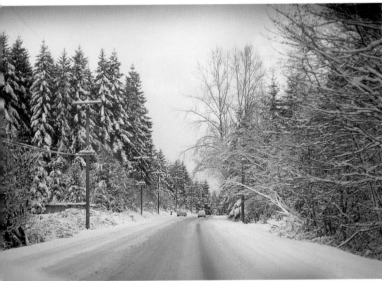

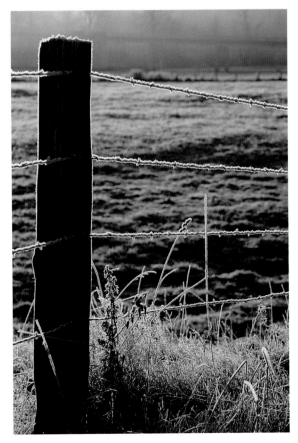

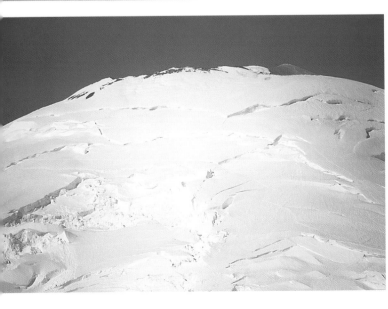

Mountains

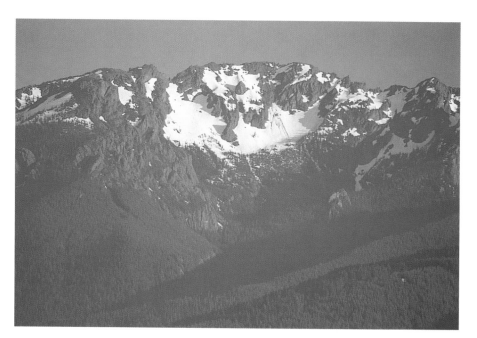

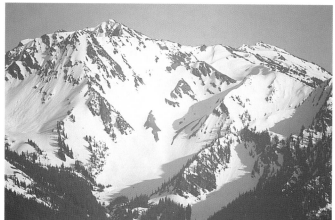

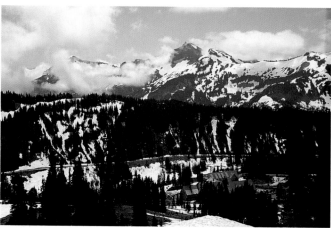

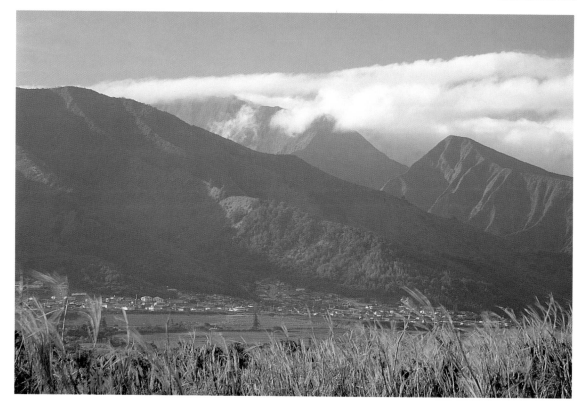

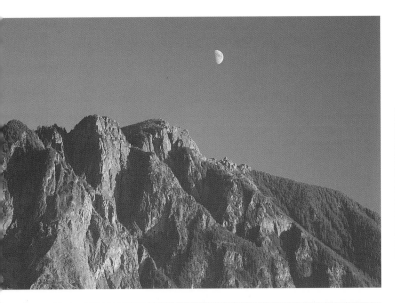

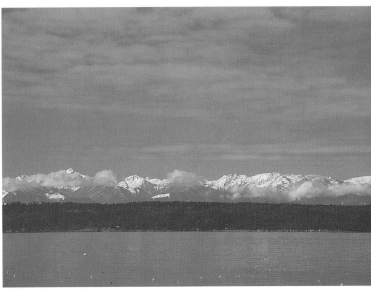

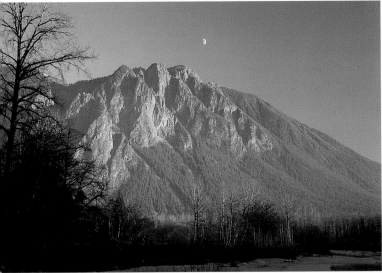

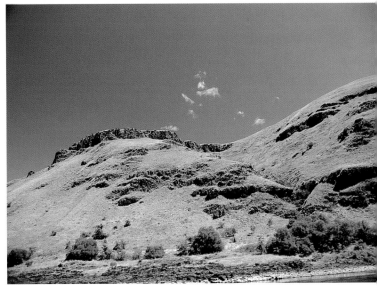

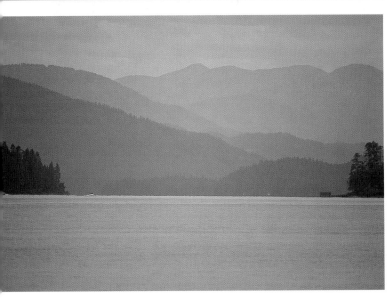

Mountains

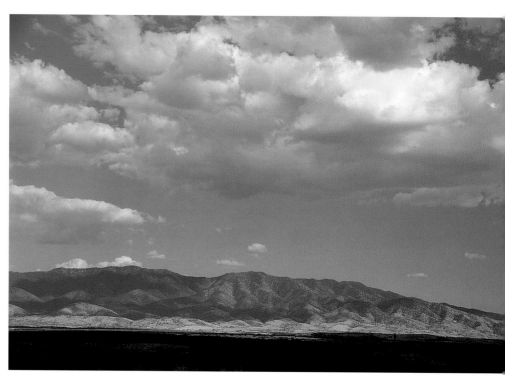

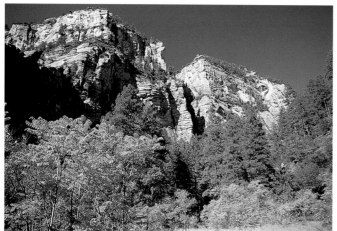

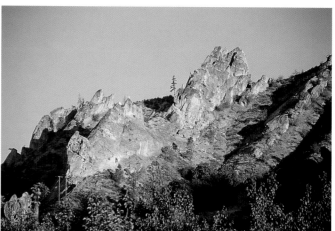

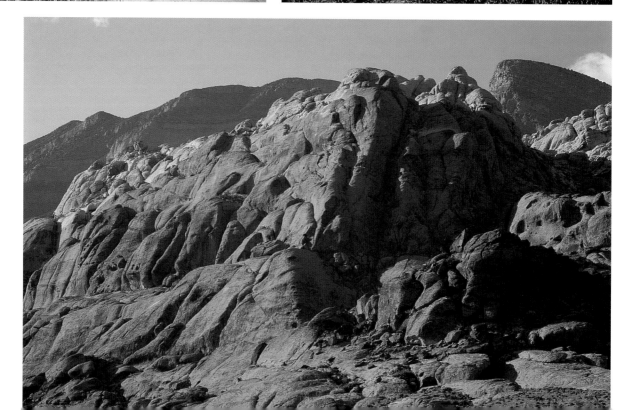

Deserts

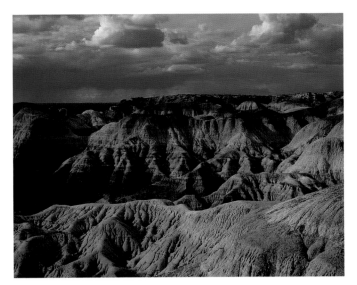

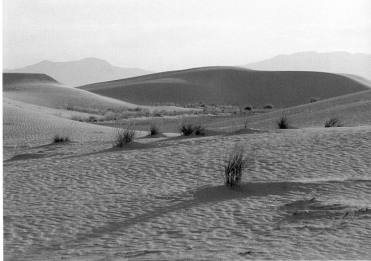

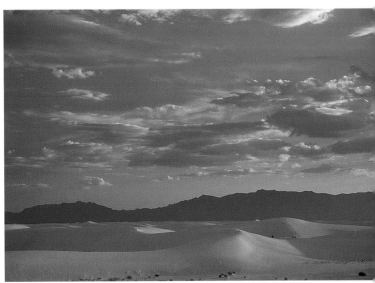

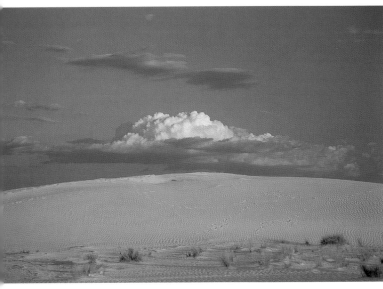

Barns and Fields

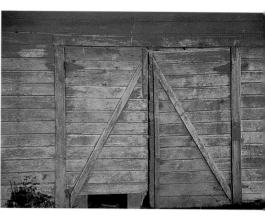

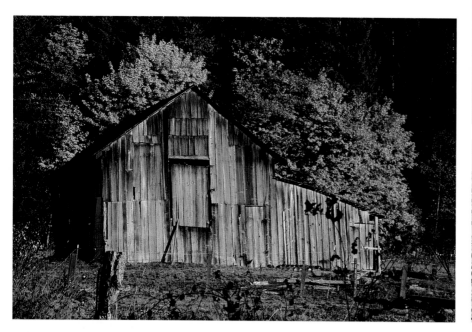

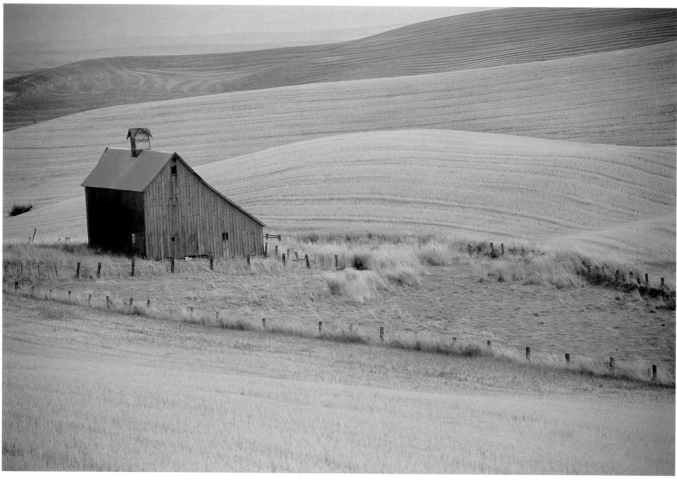

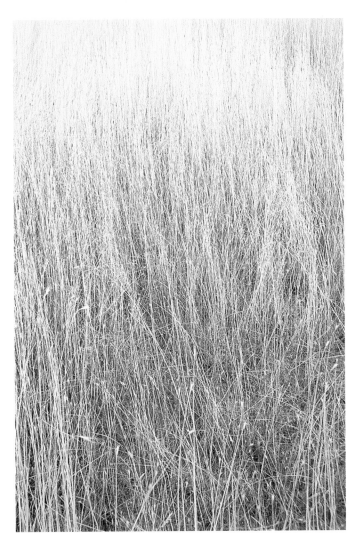

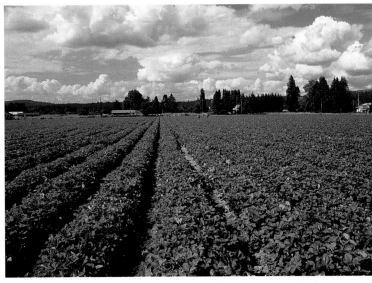

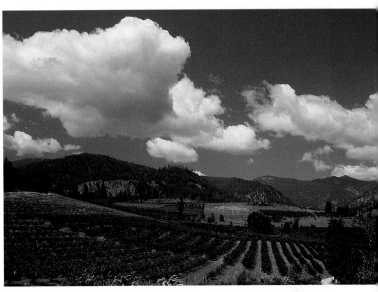

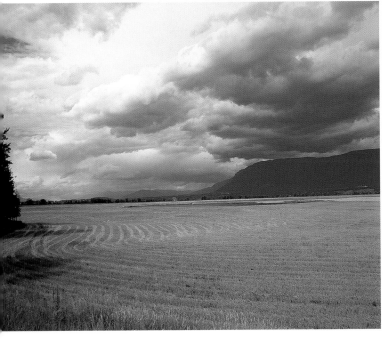

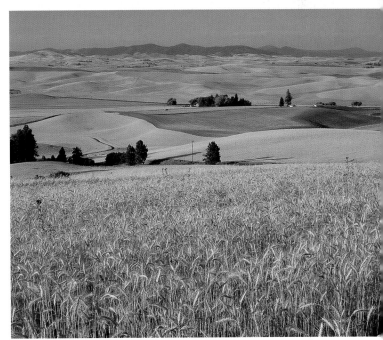

Meadows

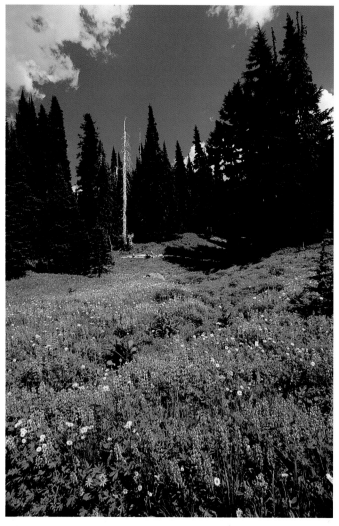

Autumn Scenes

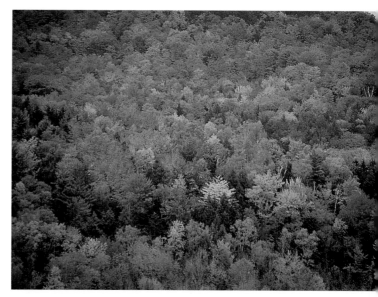

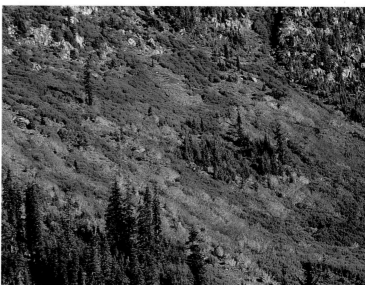

Seascapes

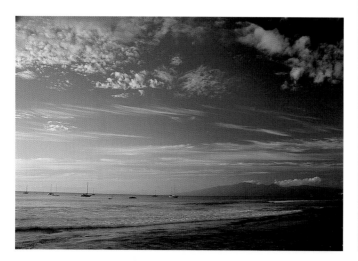

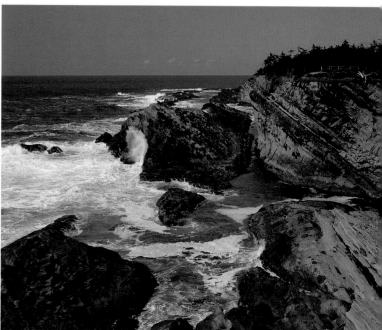

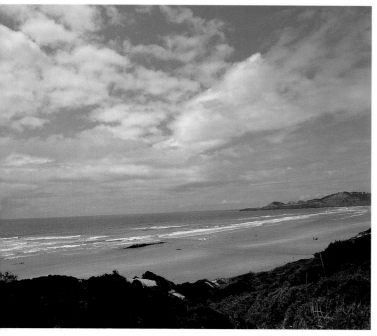

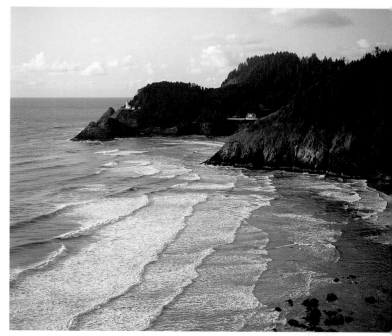

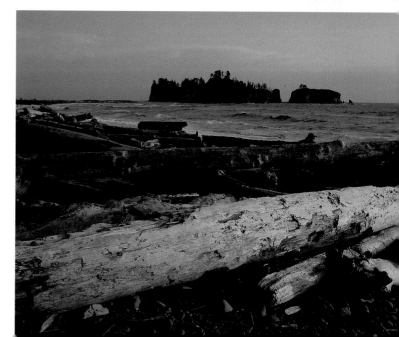

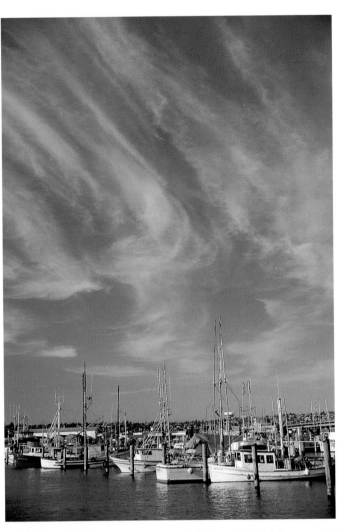

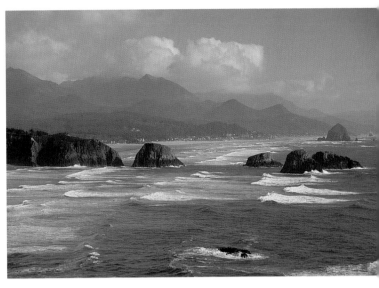

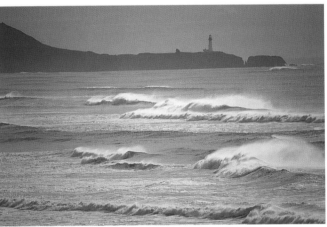

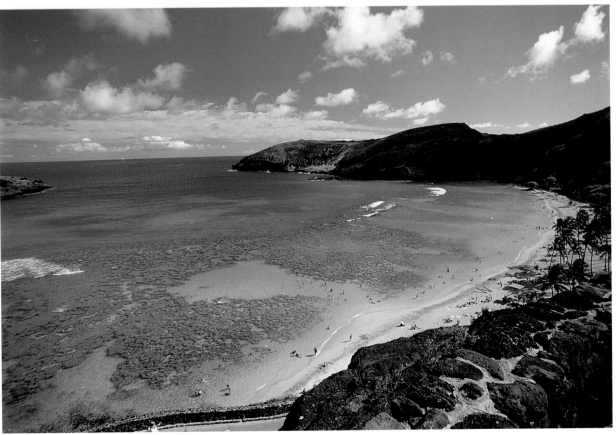

Winter Silhouettes

Materials

Surface
18" × 24" (46cm × 61cm) white Wallis museum-quality sanded paper

20" × 30" (51cm × 76cm) foamcore board

Brushes
1½-inch (38mm) flat

Nos. 2 & 5 rounds

Color Palette

Nupastel Pastels

Blue Green 288-P; Buff 276-P; Deep Cadmium Yellow 257-P; Lemon Yellow 217-P; Light Blue 235-P; Light Sap Green 268-P; Orchid 304-P; Persian Rose 214-P; Plum 324-P Red Violet 234-P; Rose Pink 246-P; Sepia 293-P; Ultramarine Blue 265-P; Violet 224-P

Sennelier Pastels

Apple Green 208; Blue Violet 335, 336; Cassel Earth 412; Cobalt Blue 353, 357; Cobalt Violet 365, 366; Coral 923; English Blue 745; Indigo Blue 133; Iridescent Gold Yellow 802; Iridescent Lemon Yellow 803; Madder Violet 309, 311, 313; Naples Yellow 102; Nasturtium Orange 933; Nickel Yellow 904; Orange Lead 40; Persian Red 782; Purple Blue 283, 285; Purple Blue 281; Purple Violet 327; Purplish-Blue Gray 478; Sapphire Blue 622; Steel Blue 714; Turquoise Blue 713; Ultramarine Deep 394; Violet Brown Lake 444; Violet Magenta 941, 947

Unison Pastels

Blue Violet 11

Schmincke Pastels

Deep Violet 059B; Madder Lake 045H; Light Green 071M; Mossy Green No. 1 0750; Permanent Yellow 0020; Rose Madder 047H; Ultramarine Light 0620; Reddish Violet Deep 055D

Other
2-inch (5cm) masking tape

Soft vine charcoal

Artists' paint thinner

Container for paint thinner

Straightedge

Newspapers

Paper towels

Take a monochromatic image of bare trees in stark silhouette against a cold, foggy December morning and combine it with a deliberately overexposed, out-of-focus photo of colorful leaves on a bright autumn morning day, and—*presto!*—you have this eye-catching pastel painted by artist Paulette Johnson.

A silhouetted subject with a featureless white background makes a perfect subject for "sandwiching" with a vibrant background. Any number of backgrounds can be successfully sandwiched with silhouettes—clouds, water, sunset—as long as the background is slightly underexposed and does not overpower the silhouetted subject.

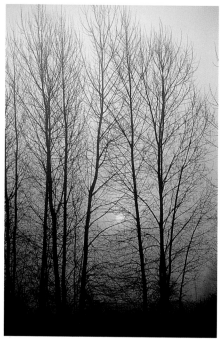

Reference Photo

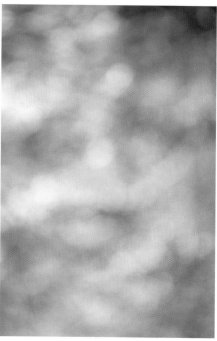

Reference Photo

Composite Photo

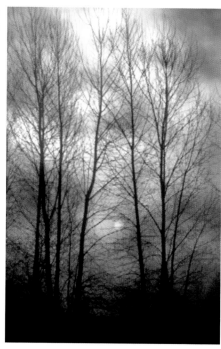

1. Tone Paper and Sketch Trees

Divide the paper into three horizontal sections, drawing the center horizon as a flattened U-shape. Fill in the bottom area with Nupastel Red Violet 234-P, the middle with Rose Pink 246-P, and the remaining area at the top with Deep Cadmium Yellow 257-P.

Attach the paper to the foamcore with masking tape. Place the foamcore flat on some newspapers and pour the paint thinner into a container.

Using the 1½-inch (38mm) flat brush, apply paint thinner over the entire surface of the paper. Start in the yellow and move down the paper using quick horizontal strokes before the paint thinner dries.

Lift the foamcore, keeping it flat, and gently tilt to blend. Use the no. 5 round brush for additional light blending along the horizons.

Set the foamcore flat and allow the paper, tape and foamcore to dry completely. If the paper buckles, gently lift the top of the tape and stretch the paper flat again.

Sketch trees lightly with charcoal, drawing the tree trunks and main branches. Don't put in every branch at this time.

Use your no. 2 round brush to gently remove charcoal for corrections. Do not use an eraser. As you work, you'll need to wipe off the pastel sticks with paper towels to keep colors clean.

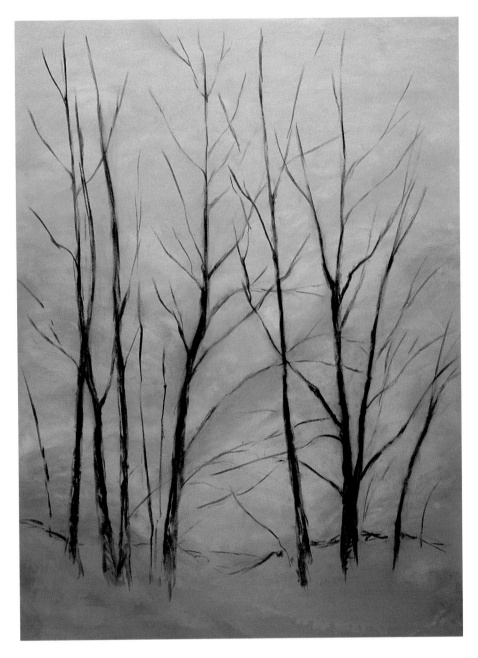

2. Sketch Background Shapes in Sky

From this point on, work with the paper on an upright easel.

Look for the large simple shapes in the background sky and sketch them with Nupastels. Sketch the contrasting warm and cool shapes of the sky, mist and clouds.

Apply diagonal strokes moving up to the right. Go ahead and lay different colors in next to each other, but don't blend them yet. Allow some of the toned paper to show through; this will add depth to the painting.

Leave the red-violet toned foreground at the bottom as is. In the cool sky area above the foreground, apply strokes of Violet 224-P, Ultramarine Blue 265-P and Light Blue 235-P.

In the warm area with sunlight, apply strokes of Rose Pink 246-P, Persian Rose 214-P, Deep Cadmium Yellow 257-P, Lemon Yellow 217-P and Buff 276-P. Allow yellow-toned paper to indicate sun.

In the middle third of the painting in the cool area, use strokes of Violet 224-P, Ultramarine Blue 265-P, Light Blue 235-P, Persian Rose 214-P, Orchid 304-P, Light Sap Green 268-P and Blue Green 288-P.

Moving up to the warmer area, use Lemon Yellow 217-P, Deep Cadmium Yellow 257-P, Buff 276-P, Rose Pink 246-P and Orchid 304-P

In the top third of the painting in the cool areas, use strokes of Violet 224-P, Ultramarine Blue 265-P, Orchid 304-P, Light Sap Green 268-P and Blue Green 288-P.

In the warm areas, use Buff 276-P, Lemon Yellow 217-P, Deep Cadmium Yellow 257-P, Rose Pink 246-P and Orchid 304-P.

Apply a few strokes of Plum 324-P and Sepia 293-P to the tree trunks and add a few branches.

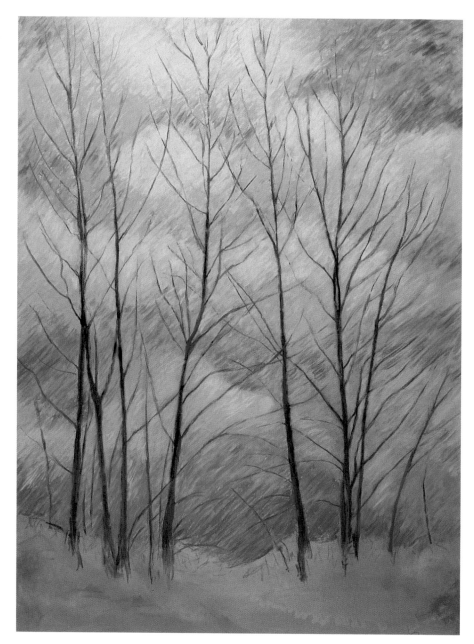

3. Establish Sky Shapes with Soft Pastels

Use soft pastels to develop the warm and cool areas of the sky. Apply loose diagonal and vertical strokes to suggest the shape and movement of clouds, fog and mist.

The sanded texture of the paper will allow you to add several layers of colors. Apply layers with a light touch. Do not use your fingers to blend colors. Use pastels only on the surface. Do not over-blend. Apply darker values of each color first; lighter values should be on top.

In the blue sky area above the foreground, apply Unison Blue Violet 11 and Sennelier Cobalt Blue 357. Apply vertical strokes moving up from the foreground with Sennelier Madder Violet 309, Cobalt Violet 365, and Cobalt Blue 357 to add texture.

In the blue sky area in the middle of the painting use Sennelier Cobalt Blue 357, Cobalt Violet 365, and Schmincke Light Green 071M on the left. In the center area use Sennelier Steel Blue 714, English Blue 745, Schmincke Ultramarine Light 0620 and Light Green 071M. On the right in the violet area use light layers of Sennelier Cobalt Blue 357 and Cobalt Violet 366. In the blue area use Sennelier Turquoise Blue 731 and Cobalt Blue 357.

In the upper third of the painting in the cool sky area, on the left and between clouds, use Sennelier Cobalt Violet 365 and 366, Cobalt Blue 357, and Schmincke Light Green 071M. In the upper right corner apply layers of Sennelier Madder Violet 311, Cobalt Violet 365 and 366, Cobalt Blue 357, and finally touches of Madder Violet 309.

In the warm cloud area with the sun, apply light strokes of Sennelier Madder Violet 313 on the left and right. Add a few strokes of Sennelier Ultramarine Deep 394 on top of Madder Violet 313.

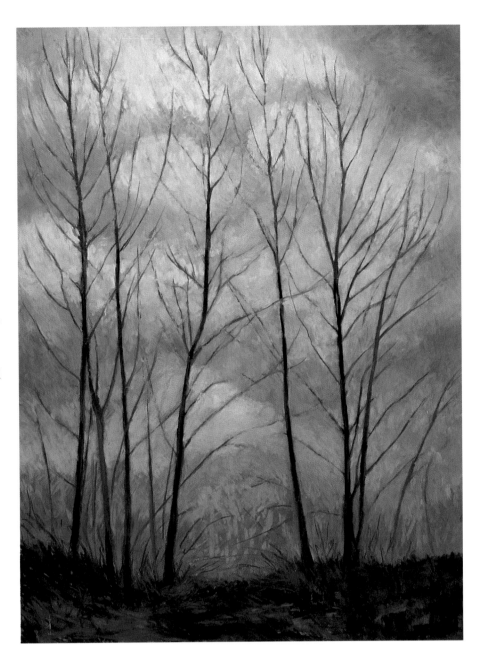

In the center area add strokes of Sennelier Orange Lead 40 and Naples Yellow 102.

In the yellow cloud area in the middle of the painting, use touches of Sennelier Blue Violet 336 on the left, Naples Yellow 102 in the middle, and Persian Red 782 with a layer of Nasturtium Orange 933 on the right.

In the upper cloud areas use light strokes of Schmincke Permanent Yellow 0020, Rose Madder 047H and Light Green 071M.

In foreground, apply loose strokes of Sennelier Cassel Earth 412 and Indigo Blue 133.

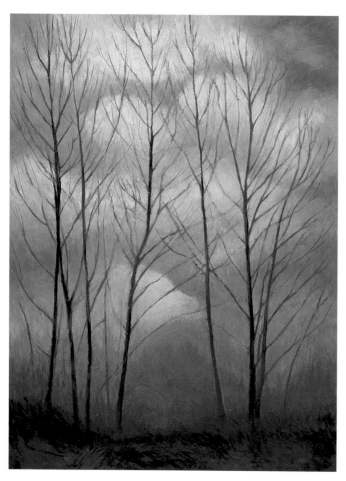 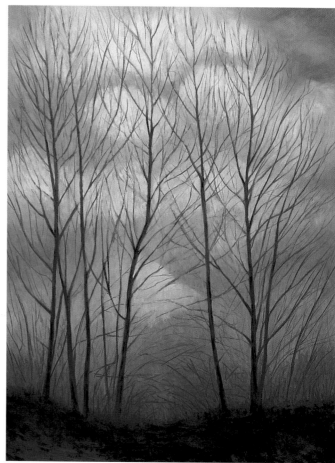

4. Develop Background and Foreground

To the sky area, add more light layers with soft Sennelier and softer Schmincke pastels. In the sky area below the sun, apply a layer of Sennelier Sapphire Blue 622 to add more intensity. Add Sennelier Violet Magenta 947 and Madder Violet 311 to lower violet area.

In the warm cloud area with sun, soften cloud edges on left and right with Sennelier Blue Violet 335. In the middle area add light strokes of Sennelier Coral 923, Orange Lead 40, Nasturtium Orange 933, Naples Yellow 102, Purple Violet 327 and Persian Red 782.

In the blue sky area above the cloud with sun, add Sennelier Sapphire Blue

622 and Steel Blue 714. Add light strokes of Schmincke Mossy Green no. 1 075O and Sennelier Steel Blue 714 to blue-green area.

In the upper green areas soften with Schmincke Mossy Green no. 1 075O and Light Green 071M. In upper violet areas add touches of Sennelier Madder Violet 311, Madder Violet 313, Purple Blue 283 and 285, and Blue Violet 335. In upper cloud areas soften with Sennelier Apple Green 208, Orange Lead 40, Nasturtium Orange 933, and Schmincke Madder Lake 045H.

Touch up and add branches with Nupastel Violet 224-P.

Add strokes of Sennelier Cassel Earth 412 and Indigo Blue 133 to the foreground and the trunks of the trees.

5. Define Trees and Branches

Use Nupastel Violet 224-P to further define the upward branches, making branches thinner as they move outward from the trunk of the tree.

Add strokes of Sennelier Indigo Blue 133 and Schmincke Deep Violet 059B to area above the foreground to suggest distant trees and branches. Foreground trees should be darker in value than distant trees.

Add touches of Schmincke Deep Violet 059B to the tree trunks and Nupastel Violet 224-P to distant trees.

Add strokes of Sennelier Indigo 133 to indicate branches above the foreground.

Soften foreground areas in shadows with colors used in that area.

6. Add Finishing Touches

Use Sennelier Iridescent Lemon Yellow 803 on top of Naples Yellow 102 and a touch of Schmincke Permanent Yellow 002O to suggest glow of light from the sun. Add light strokes of Sennelier Iridescent Gold Yellow 802 in cloud area to the left of the sun. Blend lightly with Sennelier Orange Lead 40. Soften to the left of sun with Sennelier Blue Violet 335. Add strokes of Sennelier Madder Violet 311 on the right to suggest mist rising.

Add Sennelier Cobalt Blue 353 to lower sky area.

In the foreground, add diagonal strokes of Sennelier Cobalt Violet 361, Cassel Earth 412, Purplish-Blue Gray 478, Schmincke Deep Violet 059B and Schmincke Reddish Violet Deep 069D. Next add vertical strokes using the same colors. Lightly blend. Add light strokes of Sennelier Purple Blue 281 and Violet Magenta 941 to suggest the texture of grasses and shaded foreground.

Cloud the area to the left of the sun with very light touches. Add a medium orange color, like Nasturtium Orange 933, to warm this area.

Look for areas of branches that need to be softened. Lightly brush off pastel that is too dark on the branches.

Add strokes of Nupastel Orchid 304-P and Nupastel Violet 224 P to suggest distant branches. Add thin strokes for the smallest branches at the tops of the trees and other branches.

Add touches of Sennelier Violet Brown Lake 444, Purple Blue 281, Cobalt Violet 361 and Schmincke Reddish Violet Deep 069D to the tree trunks in the shade so they will not appear flat.

Touch up sky areas and add light values using Schmincke Permanent Yellow 002O and Sennelier Nickel Yellow 904, Blue Violet 336 and Violet Magenta 947.

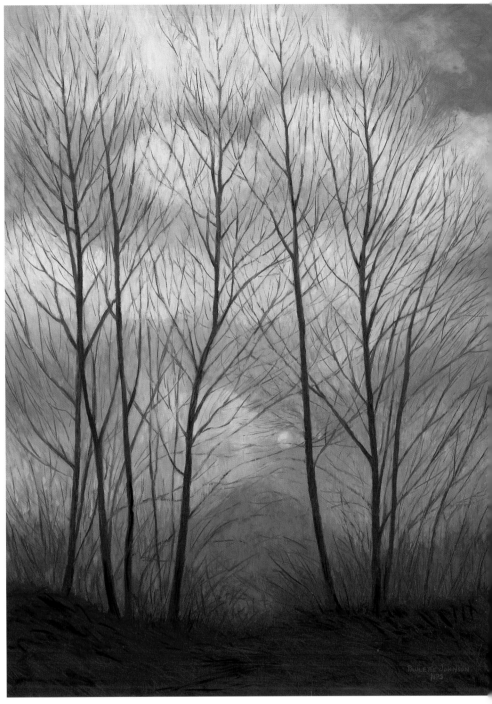

Winter Silhouettes
Paulette Johnson
24" × 18" (61cm × 46cm)
Pastel and charcoal on Wallis museum-quality sanded paper

Abstracts

Beverly Fotheringham

Beverly Fotheringham has been concentrating on painting in the watercolor media since 1997 and has earned distinction as a signature member of both the National Watercolor Society and the Northwest Watercolor Society. She has won numerous awards for her work in juried shows throughout the United States. Beverly's unique work is gaining her increased visibility as one of the leading new watercolor artists in the Pacific Northwest. Beverly received her formal training at the Art Center College of Design in Los Angeles, and she received her BA degree in fine arts from California State University Fullerton.

Pia Messina

Pia Messina was born to a conservative family in Turin, Italy, at a time when a career in art was considered unsuitable for a girl. After raising two sons, she moved to the United States with her husband and attended the National Academy of Design. She achieved life membership in the Art Student League and signature membership in the New Jersey Watercolor Society. Pia moved to the West Coast in 1989, and gained signature membership in the Northwest Watercolor Society, Montana Watercolor Society, and the National Watercolor Society. Pia lives and works in Bellevue, Washington, enthusiastic about charting new ways.

Liana Bennett

Liana Bennett's art career began early: In high school, she worked on school newspapers, illustrated school workbooks and painted backdrops for school plays, all while selling several of her paintings on the side. Liana's paintings and multimedia work have received both national and regional honors and awards. She has been a teacher and demonstrating artist for 30 years and continues to find all aspects of the art world challenging and exciting. Since 1984, Liana has been teaching at the Arts Umbrella in Bothell, Washington, which she helped found.

Steve Whitney

Steve Whitney is an award-winning painter in oil, acrylic and watercolor, with paintings in all three media juried into national shows. He is a juried associate member of Oil Painters of America and of the Puget Sound Group of Northwest Painters. He is a signature member of both the Montana Watercolor Society and the Northwest Watercolor Society. Steve makes his studio just outside Woodinville, Washington, and is represented by Kaewyn Gallery in Bothell, Washington.

Paulette Johnson

Paulette Johnson is a Signature Artist with the Northwest Pastel Society. She has exhibited in several juried shows, including the 14th Open International Exhibit at the Harbor Gallery in Gig Harbor and the 13th Open International Exhibit, "Contemporary Pastel Artists," at the Friesen Gallery in Seattle. Her paintings have been in numerous juried exhibits in Washington and Oregon, including the Art in Port Townsend Annual Juried Art Show and the Eastside Association of Fine Arts exhibitions. She has won several first place awards at regional juried shows and art festivals. Paulette currently serves as Vice President and a member of the Board of Directors of the Northwest Pastel Society.

Index

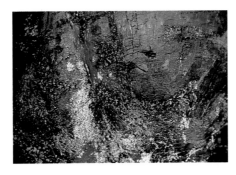

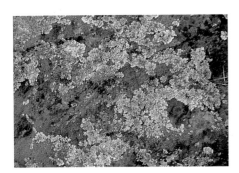

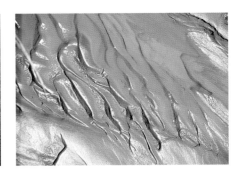

Check out these other great titles *from* North Light Books!

Dory Kanter's inspirational guidance is perfect for both beginning and experienced artists alike. *Art Escapes* gives readers a fun, easy-to-execute plan for building an "art habit." Inside, you'll find daily projects for drawing, watercolor, mixed media, collage and more. With *Art Escapes*, you'll experience heightened artistic skill and creativity, and find the time to make a little bit of art everyday.

ISBN 1-58180-307-9, hardcover with concealed wire-o, 128 pages, #32243-K

Good composition and design is the underlying foundation of any successful painting. Through step-by-step instruction, author Pat Dews shows how successful painters in a variety of styles and mediums—including watercolor, watermedia, pastel, collage and more—use design principles in their own unique ways to create gorgeous works of art. Hands-on advice will help you improve individual paintings and finish good starts. You will discover how to compose beautiful paintings while being as creative as you want to be.

ISBN 1-58180-303-6, hardcover, 144 pages, #32239-K

Find these and other great North Light titles from your local art & craft retailer, bookstore, online supplier or by calling 1-800-448-0915.

Composition is one of the most important elements to any painting, but it can also be one of the most intimidating. In this simple resource, Greg Albert boils it all down to one golden rule: Never make any two intervals the same. He demonstrates this fool-proof "rule" with clear, concise diagrams and sketches, plus samples from today's top painters. Artists of all levels will find this secret to great composition easy to remember and even easier to use.

ISBN 1-58180-256-0, paperback, 128 pages, #32097-K

Discover Betty Carr's time-tested secrets for capturing the awe-inspiring qualities of light on canvas. You'll learn how to use light to create depth, form, mood and atmosphere in all your paintings. 12 complete step-by-step demonstrations with close-up painting details and keys for "seeing" light and true color will guide your journey in mastering light. The wide variety of innovative techniques and exercises makes it easy to understand this often confusing topic.

ISBN 1-58180-342-7, hardcover, 144 pages, #32312-K